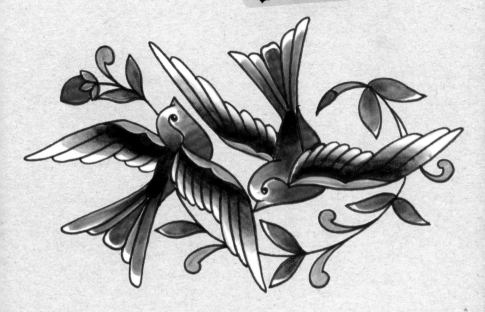

Dominique Holmes

THE
PAINTED
LADY

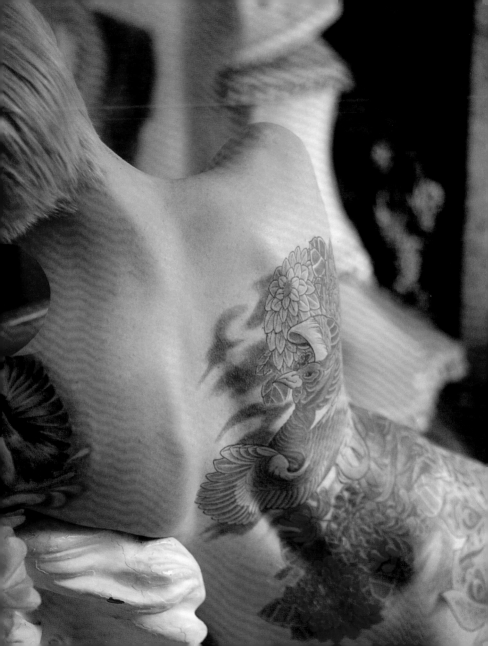

The art of tattooing the female body

THE
PAINTED
LADY

LONDON · NEW YORK

Dominique Holmes

Design and Styling Luis Peral-Aranda
Editor Ellen Parnavelas
Head of Production Patricia Harrington
Art Director Leslie Harrington
Editorial Director Julia Charles
Hair styling Moises Salas
Make-up artists Hannah Wing and
Layla Drury
Indexer Claire Hodgson

First published in 2013
by Ryland Peters & Small
20–21 Jockey's Fields
London WC1R 4BW
and
519 Broadway, 5th Floor
New York, NY10012
www.rylandpeters.com

10 9 8 7 6 5 4 3 2 1

Text and illustrations © Dominique Holmes
2013.
Design and commissioned photographs ©
Ryland Peters & Small 2013
Photographs on pages 16,17, 60, 63, 64, 65, 102,
123 and 125 © Scarlett Crawford.

ISBN: 978 1 84975 369 2

A CIP record for this book is available from
the British Library.

Library of Congress Cataloging-in-Publication
data has been applied for.

Printed in China.

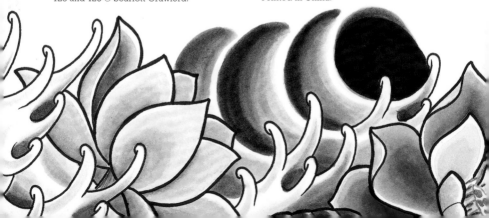

CONTENTS

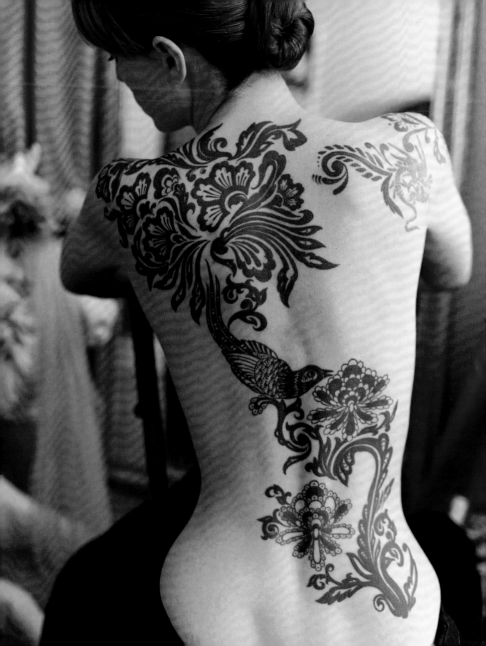

Left: Kate's backpiece is a striking mixture of a delicate subject in a graphic style.

Below right: Niesh and I are both huge fans of Billie Holiday, so of course we had her songs playing while I tattooed this portrait of the songstress on her arm.

The painted lady was once a figure of fascination associated with freak shows and circuses. She would stand alongside the conjoined twins, the lion tamer, the contortionist and the bearded lady as a creature of mystery. Most painted ladies would become heavily tattooed in order to earn a living, such as the iconic Betty Broadbent, and La Belle Irene. However, these were not the only tattooed ladies historically, as many women would go about their daily business with the outside world completely unaware of the artwork that secretly adorned their skin.

Today's painted lady brings an entirely different figure to mind. The archaic opinion of the tattooed woman as a freak or a misfit is on its way out. In the twenty-first century, the tattooed woman is a successful business owner, a fashion icon, an actress, a lawyer, a musician, an artist, an editor, a teacher, an executive, a mother, and she wears her tattoos with pride. Her tattoos are a statement of her individuality, her femininity and her complete confidence in who she is and what she represents. Her tattoos enhance her beauty and the world has begun to acknowledge and appreciate that too. The time has now come for the 'painted lady' to be celebrated for the beautiful woman that she is.

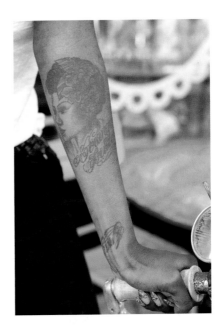

It is impossible to overlook the evolution that has happened in the art of tattooing over the last few decades. From its early purpose in many parts of the world as a way of marking out a criminal, the tattoo has emerged from lowly beginnings to become a recognized form of art that excludes none, especially not women.

As women have fought for gender equality, we are now beginning to feel that we are as entitled to do as we please with our lives and our bodies as our male counterparts do and that is reflected in the belief that we can get tattoos when and where we want them.

While we think of women with tattoos as part of a fairly recent trend, and one that still carries the stigma of something inappropriate, we should never overlook the never-quite-confirmed stories that influential women in history, such as Queen Victoria, had intimate tattoos.

Since the 1950s, America and Europe have experienced an upsurge in the tattooing of women which has continued to intensify to this day. One woman who embodied this new expression of art and individuality was the late, great musician, Janis Joplin.

Janis Joplin was one of the first women to use her tattoos as a part of her public image. The iconic, charismatic musician had two tattoos, etched onto her by legendary American tattooer Lyle Tuttle in San Francisco. The first was a wristlet based on a fifteenth-century Florentine bracelet she wore, and the second was a heart on her breast. Having been replicated probably hundreds of times over, the bracelet has become a mark of feminism and a symbol of female strength. It is an image that channels the energy of the late Joplin who did so much for sexual equality through her music and her personality.

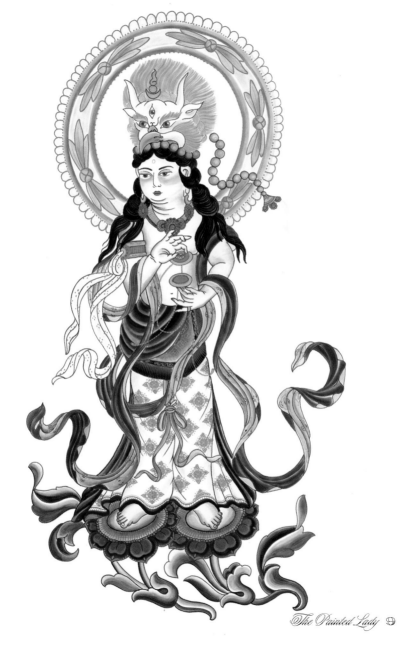

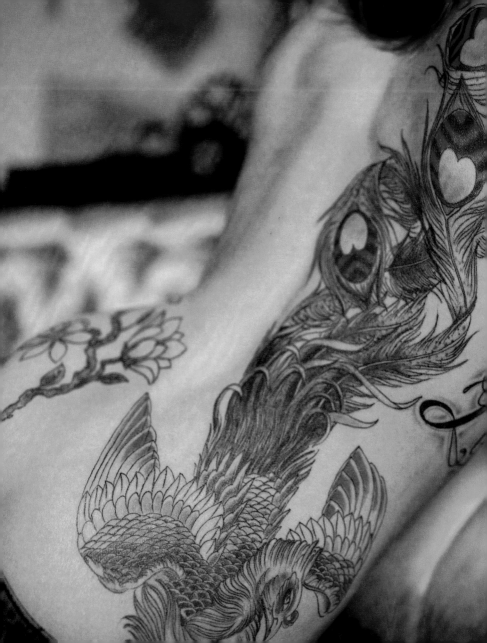

As tattoos have become more popular and accepted, women have discovered the wealth of different styles on offer – from traditional, vintage-style swallows (right), to a Japanese-style phoenix (left) and even a fusion of Eastern and Western influences (below right).

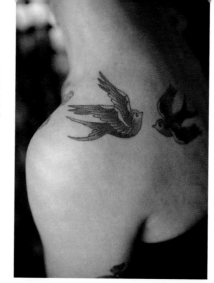

After this, with Joplin flaunting her tattoo, her style and her feminine potency all over the world, the famous tattooer Lyle Tuttle, as well as other artists, suddenly found he had increasing numbers of female clients. He credited women's liberation, the wide opportunities now granted to women all over the Western world with the freedom for women to choose to get a tattoo for themselves if, where and when they wanted. Before his retirement in 1990, Tuttle was quoted as saying that 'Women made tattooing a softer and kinder art form.'

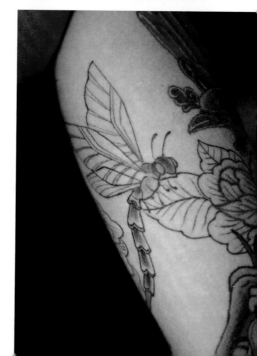

Right: Originally, this tattoo was only two roses, but it didn't take long for Ellen to come back wanting more. We decided to add a key to accentuate the fine linear details, and leave plenty of opportunity to extend it further in future.

Today we are inundated with strong, successful and brilliant tattooed women who grace our screens, our stereos, our bookshelves, and our minds; their body art a part of who they are. Take a moment to think of the lost talent of British songstress Amy Winehouse, and you will remember an extraordinary voice radiating from her doll-like figure adorned with vintage-style tattoos; it was as if she were literally wearing her soul for the world to see. From Princess Stephanie of Monaco to Samantha Cameron, pop singers Pink and Rihanna, Beth Ditto and Scissor Sisters' Ana Matronic, as well as actresses such as Scarlett Johansson and Sandra Bullock, the tattooed female surrounds us, making it a completely natural phenomenon in today's society – with tattoos as likely to appear on an award-winning, public rolemodel as on your next-door neighbour. Gone are the days where a tattooed woman would automatically be associated with gangs of bikers (although many still are, and will wear that label with pride – I have had the privilege to work alongside one such woman and I loved the experience) or assumed to be a criminal, or somehow a lower class of woman. Even right at the higher end of British society, namely at events such as Royal Ascot and even the royal garden parties at Buckingham Palace, tattoos are accepted. We have begun to move away from the stereotypes that shrouded the image of a tattooed woman for the majority of the last century.

In 2011, global toy brand Mattel brought out a limited edition tattooed Barbie doll, giving the iconic toy an exotic, updated look. The doll was instantly popular and sold out almost immediately. We have all known Barbie as a beach babe, a princess, a doctor,

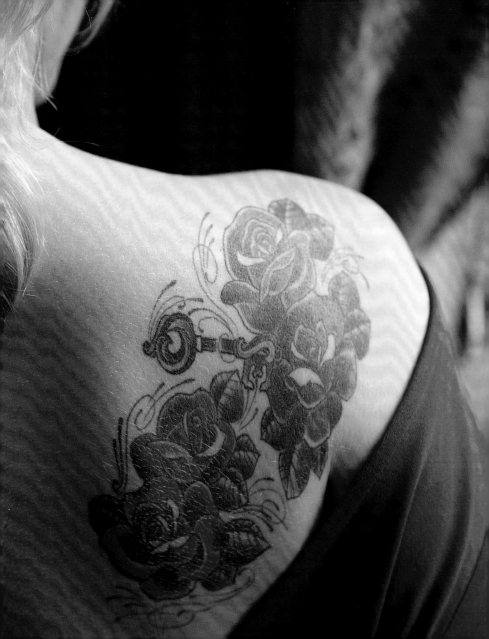

a horserider, a gymnast, a teacher; but now Barbie has tattoos - a sure sign if ever there was one that tattoos on women are not only accepted, but totally cool. If only it had been released in the 1980s, a generation of us wouldn't have had to draw tattoos on our Barbie dolls.

So, 'What is a female tattoo?' I often hear people say. 'What tattoos do women get?' As if it is as simple as blue for a boy, pink for a girl. My answer is always the same: there is no such thing as a female tattoo. The subjects I tattoo on women could be, and often are, tattooed on men as well. I specialize in Eastern tattoo styles - Japanese, mehndi, and Tibetan artworks executed with a Western twist and I mould my designs to suit my clients, regardless of their

gender. I would estimate that women make up over one third of my client base today. They are seeking a unique piece of permanent art that represents their individuality and which they will carry with them for the rest of their lives. My clients are characteristically strong-minded, determined in their decisions and self-assured in their ideas and their choice to be tattooed. They embrace the notion that the tattoo will change their own and others' perceptions of themselves, but often the most important thing for them is that they enjoy the aesthetic of the tattoo as decoration. They embody the notion of the strong, independent woman who owns her mind and body and does what she wants, for herself.

> "Getting tattooed always gives me a great confidence boost. The bigger the tattoo, the longer the high!"
>
> Tove

From the vintage style of the old Western traditonal tattoos and the nautical imagery of Sailor Jerry's designs, to a whole other realm of mehndi and traditional Japanese tattooing, and everything in between, tattoos have become the modern woman's oyster.

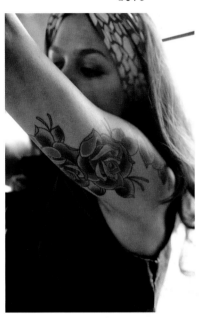

Since I started tattooing in 2002, I have noticed a huge change not only in the number of women who want tattoos, but in what they want from their tattoo. The days of women feeling they should just stick to having a small tattoo, somewhere they can hide it away, where it won't be embarrassing when they get old, seem to be a thing of the past.

Today, women want big, beautiful pieces of art that they can show off now and for the rest of their lives, something that simply enhances what they already own. When I have a consultation booked with a female client, I know I am as likely to hear her ask me for a Japanese full-sleeve design or a back piece as a discreet single red rose on her wrist. Women know that they have the choice to get whatever tattoo they want, wherever they want, whenever they want to.

Tattoos will never be to the taste of everyone. There will always be men who say they believe tattooed women are trashy, or women who feel that we are vandalizing our bodies, and we will always have to listen to those who disapprove. However, we don't choose our tattoos based on the opinions of anyone but ourselves. There is a phrase often uttered within the tattooed community:'If I have to explain my tattoos, you won't understand anyway.'

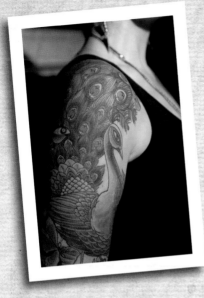

"My peacock half-sleeve was my first tattoo to be in a really prominent place, and so I really wanted the piece to say a lot about me. A lot of my tattoos are related to Buddhism and Eastern culture and I was drawn to peacocks as the national bird of India. The butterflies were inspired by a song lyric: butterfly child so free and so wild.

"I'm a tribal belly dancer, which is a very earthy sacred dance, and I wanted my tattoo to be representational of this. Although it has the plumage of a peacock, I felt it would be more appropriate to go for peahen colours to keep the female balance.

"I find my tattoos evoke a lot of positive interest. People often stop and compliment me and ask about them, and I feel as though they connect with my tattoos. While they do tell a story, they are mainly beautiful pictures that I'm wearing on my skin.

"All of my tattoos have been done by female artists, and I think it's great to see the popularity of tattooing spreading amongst women."

Layla

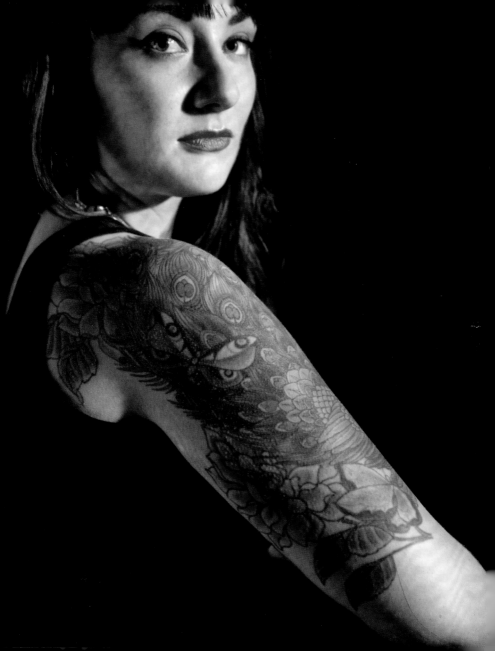

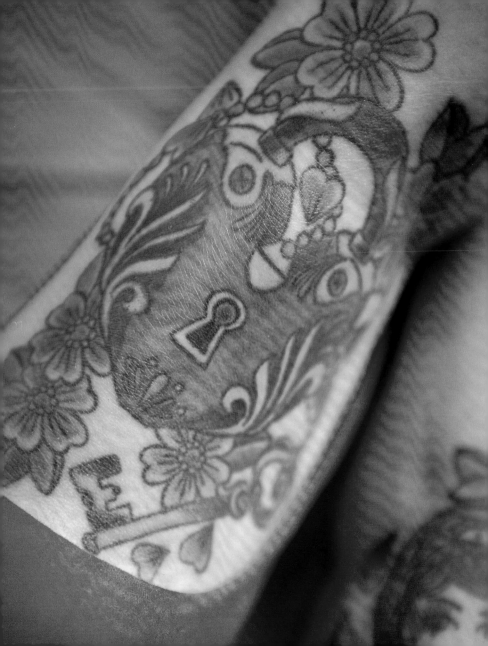

Vintage

Recognized as vintage-style, the beautiful and decorative old-fashioned images of roses, hearts, pin-ups and gypsy ladies began almost one hundred years ago. The style is often referred to as old school, Western traditional or traditional tattooing and, though it comes from very humble beginnings, it is still very popular today with both men and women.

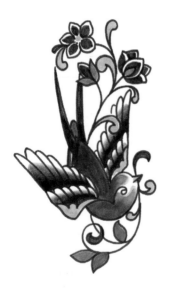

Along with the traditional Japanese style, the Western traditional tattoo is arguably the most recognizable and popular form of tattooing today. Instantly identifiable by its bold outlines containing block colours, a strong use of black shading and a stylized, graphic form, traditional tattoo imagery has continued to adorn the skin across generations since it first appeared in the 1920s.

The origins of the style were born more from necessity than artistry. Early tattoo equipment was basic, inks were sparse and only a limited choice of colours were available. The designs were kept simple for ease of application because the tattooers of the time were not the skilled artists we associate with the profession today. In the early days, it was more of a trade than an art form. In fact, you would be more likely to be tattooed by a sailor or a prisoner than a trained professional. It was a straightforward process since these tattoos were one-off pieces, picked from a handful of designs on a sheet of flash.

However, this vintage or traditional style has come a long way since its early days. With the development of modern techniques and technology and the emergence of tattooers such as Norman 'Sailor Jerry' Collins, who revolutionized the traditional tattoo, the style has continued to evolve. Cleaner and finer lines, greater detail, as well as a whole spectrum of colours have made the 'traditional' style what it is today.

The original traditional tattoos were designed almost exclusively for a male client base, and it was thought that only the rose or the butterfly were suitable tattoos

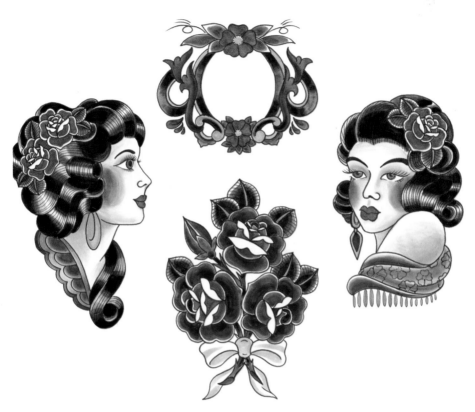

for a woman. As the number of women getting tattooed has increased, so the vintage-style has transformed to become more feminine.

Though the rose and butterfly were, and are today, an essential part of the vintage-tattoo style, it was hardly fair that women were denied the choice of artwork that was open to their male peers. Gradually, a wider range of designs for women became more popular; hearts surrounded by floral motifs; delicate swallows and sparrows, peacocks and different floral motifs appeared on sheets of flash. Women tattooers such as the iconic and heavily-tattooed Cindy Ray came to the tattoo world's attention in the 1960s and so it became more female friendly. However, it is only during the past 20 years that the vintage style has become so popular with women.

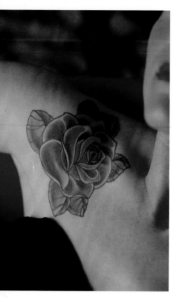

ROSE

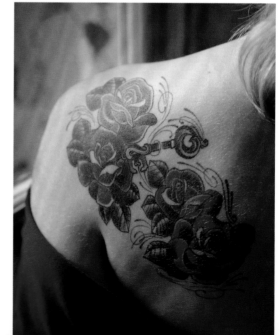

The rose is one of the most iconic images in the history of tattooing. I have probably tattooed more roses than anything else in my decade at the needle. I am the proud wearer of no less than five roses, most notably the yellow rose and diamond I have on my neck - my favourite of all my tattoos. As an object of natural beauty, it is almost futile to question why someone would want to adorn their body with such decoration, since women and men have embellished their hair, clothes and surroundings with roses for centuries. I will look further into the meanings behind the rose in different contexts later on, but in traditional tattooing, the rose was a symbol of love, inked for the wearer as a declaration of his or her feelings towards another.

Above, right and far right: Will there ever be a more classic tattoo than the humble rose? Positioned on the collar bones, it takes on the look of a corsage; or on the shoulder, the rose takes on a subtle, personal and private decorative effect.

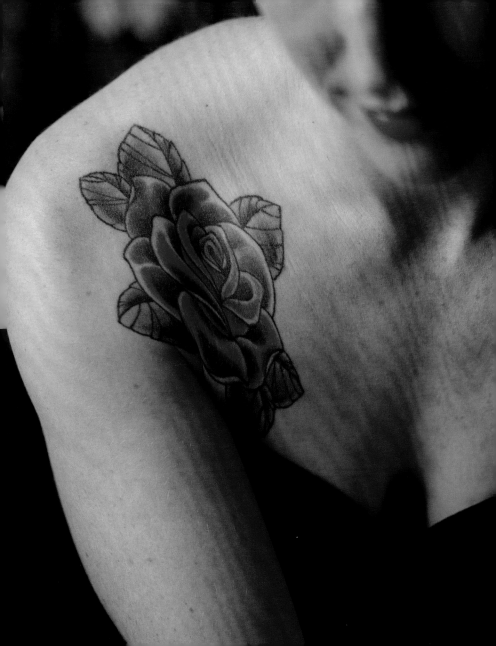

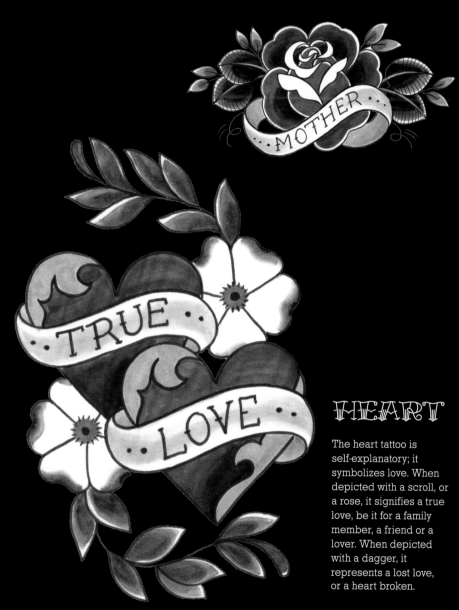

HEART

The heart tattoo is self-explanatory; it symbolizes love. When depicted with a scroll, or a rose, it signifies a true love, be it for a family member, a friend or a lover. When depicted with a dagger, it represents a lost love, or a heart broken.

PIN-UP GIRLS

With the boom in popularity for pin-up art during World War II in magazines, books, advertising, so followed the boom in popularity of the iconic pin-up girl tattoo. This type of tattoo has become a tool used to express something personal through the depiction of something beautiful.

Over the years, I have found that my customers want the girls depicted in their pin-up tattoos to represent their lovers, or someone close to them. They often ask me to add personal touches to the design of the girl by making her a brunette, for example, or show her wearing a pair of dancing shoes, or an apron – in whichever way they best remember or most fondly think of the person their pin-up is bringing to life.

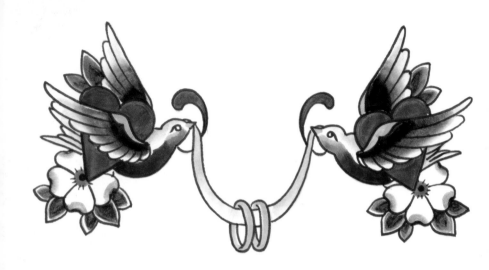

SPARROW

Not to be confused with the traditional swallow tattoo, the sparrow has two very different meanings in tattooing. Sparrows are known to mate for life, so when they are tattooed as a pair, they are a representation of an everlasting love. Couples will sometimes have matching sparrow tattoos done individually, as a symbol of their commitment to one another. In the early twentieth century however, a solitary sparrow was a popular tattoo for prisoners who had been released early, as a symbol and celebration of their freedom.

GYPSY GIRL

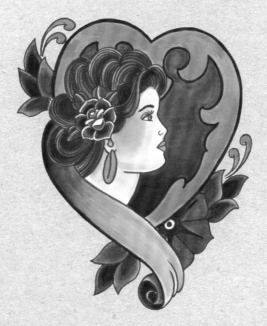

One of the most popular of the contemporary trends in the traditional style of tattooing, the gypsy girl has become known as a sign of good luck. These women's faces were often tattooed with a rose alongside them to depict the woman with whom the wearer was in love. Similar to the pin-up tattoo, it was a pictorial reminder of a love back home. More recently it is frequently chosen as a tattoo that shows beauty, although the gypsy styling such as hooped earrings and headscarves are often added to bring good fortune.

One of the main reasons that the vintage style is as popular as ever is that the symbolism of the imagery is every bit as beautiful as the tattoos. For every woman who wants a beautiful piece of artwork to decorate her body, there is one who wants to tell a story with her tattoo, and this style lends itself to both; the iconic imagery used in the style is beautiful in itself and can be used purely for decoration but it can also be used to represent something more personal or more secret.

Traditional tattooing seems fitting as a popular style today in a time when all things retro and vintage are very much *en vogue*. In an era of disposable living, where everything we own is mass-produced and verging on expiration by the time it's removed from its plastic packaging, we have a new respect for the design and lifestyle ideals of the mid-twentieth century. The built-for-life qualities of an earlier time seem attractive to us now and vintage-style tattoos share this quality. They have been around for so long and have stood the test of time, outlasting fads and tattoo fashions and have a connection with the past, so have become a symbol of an age we appreciate and admire.

The contemporary take on the vintage style is obviously a direct descendant of its original form. While the aesthetics are still in place, the style itself is now what defines it as vintage rather than the subject.

Gone are the days when the customer would choose an image from a small selection of very basic designs. Today, with the wealth of professional tattoo artists and a greater breadth of artistic interpretation, any subject can become a tattoo. As the style has developed, the range of imagery has increased and now certain images have become the modern classics of the contemporary take on vintage tattoos; hourglasses, pocket watches, lockets, magpies, owls and crowns are all becoming as customary in today's take on the style as roses, hearts and pin-ups have been for the past century.

Kob

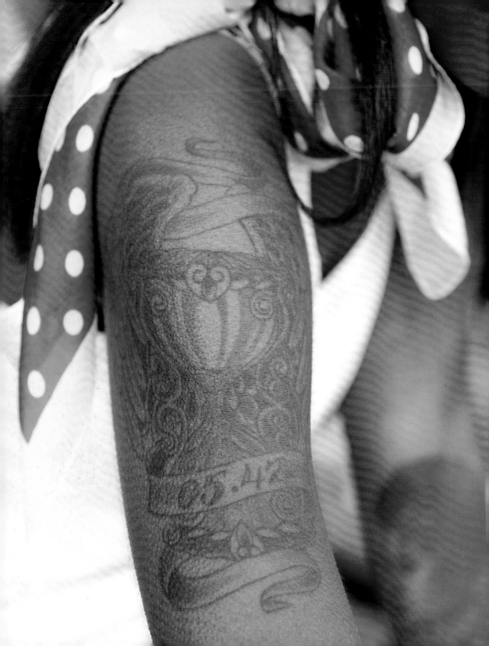

"I only have one tattoo with a specific meaning — an hourglass for my grandmother. On the day she passed away, I went into her bedroom and the clock had stopped at 05.42am. It was midday and the doctors had previously advised that she'd passed shortly before 6 o'clock in the morning. Spooky, right? I now have an hourglass with wings tattooed on my right arm. The sand is running out and '05.42' is inscribed on a scroll.

I found the process of getting this tattoo very therapeutic. My grandmother was sick for a long time and once she passed, I felt relieved. I'm not particularly religious but I fully believe that my grandmother saved my ass from a few...situations, shall we say. As clichéd as this may sound, with this on my arm, I feel as though she's always with me."

Neish

There is something about the traditional style that screams, 'You know what? If I'm going to get a tattoo, I'm going to get a real tattoo!' When the un-tattooed public picture a tattoo, they arguably imagine these vintage-style motifs. In some design circles, the style has simply become referred to as 'tattoo style'. So it cannot be overlooked that for some, particularly those who want to go all out with their tattoos, who want to make a statement that they are, in fact, embracing tattoo culture as a whole, that the vintage style is the way to go.

In recent years, this Western traditional style of tattooing has come to incorporate many other cultural references and influences, notably Art Nouveau, Realism and Japanese styles. The imagery and symbolism of the Mexican *Dia de los Muertos* (Day of the Dead) celebrations have also been embraced as part of the modern take on the vintage tattoo style.

Dia de los Muertos is a Mexican celebration which takes place each year on 30th October. The festival is a gathering to remember and celebrate the lives of friends and family who are deceased, and its historic tradition dates back beyond the Hispanic era. Gifts and offerings of marigolds (sometimes called *flor de muerto*, or flower of the dead), beautifully decorated sugar skulls and personal memorabilia are taken to private altars which are built in advance especially for this purpose with the intention of attracting the souls of the dead so that they may witness the festivities and hear the prayers and thoughts of their friends and families. Rather than a morbid mourning for the loss of the living, this celebration is more of a joyous occasion and a way of remembering and maintaining a feeling of devotion to those who have passed on.

CALAVERA

Calavera, which translates as skull but can refer to any ornament associated with *Dia de los Muertos*, are often tattooed as a mark of remembrance and dedication in this way. Alongside this, there is also the belief that possessing *calavera* can bring good fortune, and so having them tattooed is a way to carry your good luck with you at all times.

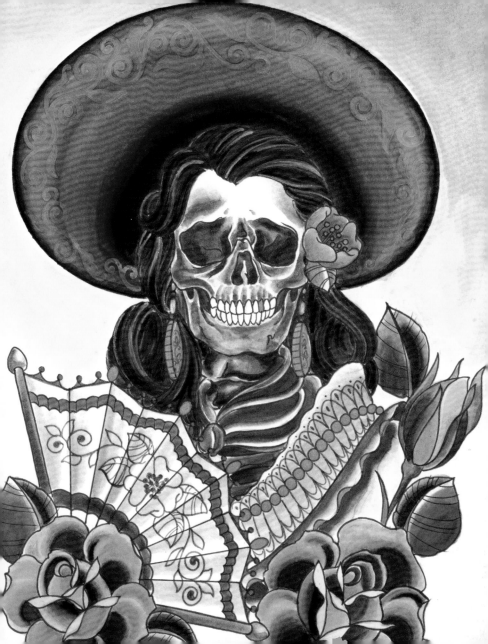

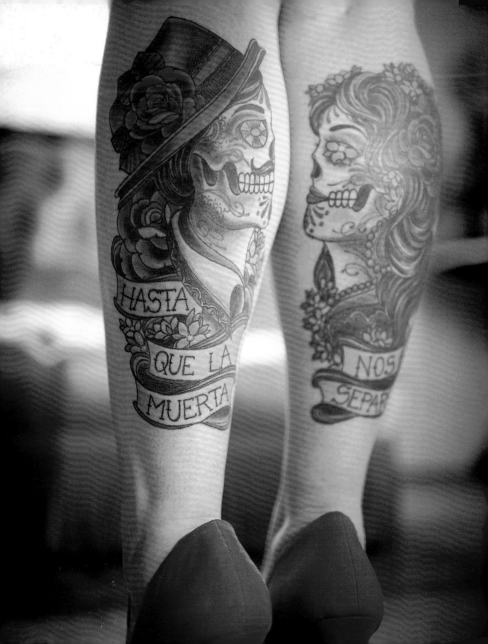

"I got the tattoos on my legs after I was married. I am not keen on jewellery and often forget to wear my rings. I wanted something to show my husband how much I loved him and that I will always love him no matter what happens. Regardless if we divorce or it ends badly, he is my first love and I will always love him. I thought long and hard about the design as I did not want to get his name tattooed so I chose this wedding scene as a symbol of my love and the hope that I have for our love.

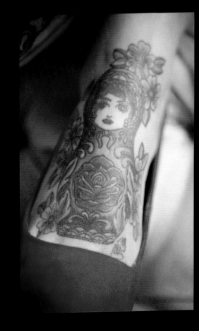

"In a strange way I do feel a little different since getting tattooed; I feel more confident and I am proud of the decisions that I have made and the images that I have chosen to be permanently displayed on my body. I am not a 'pretty girl'. I have never been thin, I have never been popular and I have always been the odd girl. But when I am showing my tattoos to someone, I do, in a way, feel pretty and more confident. I feel that by having this art tattooed on my body, I am adding to the world's beauty."

Christine

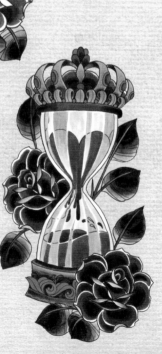

LOVE TRILOGY

So many of the traditional tattoo images symbolize love, and the slightest change in their depiction can switch the tone and the significance entirely, just like the slightest change in life can create a completely different path. The Love Trilogy – True Love, Love Life, Love Lost – depicts the lifespan of love through the heart and rose motifs: the locket is a symbol of marriage and commitment, solidifying the love; the hourglass represents the lifespan of a relationship, the time slowly running out from the moment it begins; and the dagger through the heart symbolizes heartbreak, the end of love's journey.

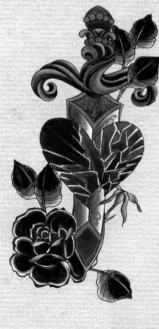

The influence of these Western traditional tattoos is obvious in a lot of my artwork and designs. I often use the simplicity and graphic nature of the style against a stark, plain background which is so recognizable from the vintage tattoo style, and reminiscent of the original tattoo flash – an aspect of tattooing which has remained virtually unchanged over the years.

The aesthetics of this style have become very popular in contemporary culture outside the world of tattooing, as many other media have begun to embrace its imagery. The instantly recognizable graphic nature and stylistic qualities combined with the strong appeal of its vintage, timeless associations have revamped these old tattoo designs into a more mainstream design genre. The new-found appreciation of tattooing and tattoo designs as an artform in its own right has seen these motifs embellishing the clothes and accessories of fashion designers such as Marc Jacobs and Louis Vuitton, as well as popular high-street brands. Collections of kitchenware, soft furnishings, ranges of stationery and greetings cards, all with vintage-style tattoo themes, have established themselves as commonplace – today's homes can be decorated top to bottom with tattoo-style imagery. The fact that tattoo designs illustrate the covers of books, records and comics across all genres is a sign that tattoo art appeals to the masses.

Over the years, I have been commissioned to create vintage tattoo-style designs for luxury bag companies, clothing stores, jewellery manufacturers, book covers and illustrations, album covers and band merchandise, and even a line of children's clothing. Surely this is proof, if ever it were needed, that the art of tattooing has spread far beyond its boundaries which, until recently, had kept it relatively underground.

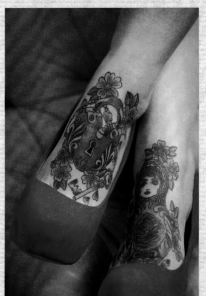

Left: The Russian doll and the locket are two of my favourite subjects to design for women. With so much opportunity for embellishment, no two could ever be the same.

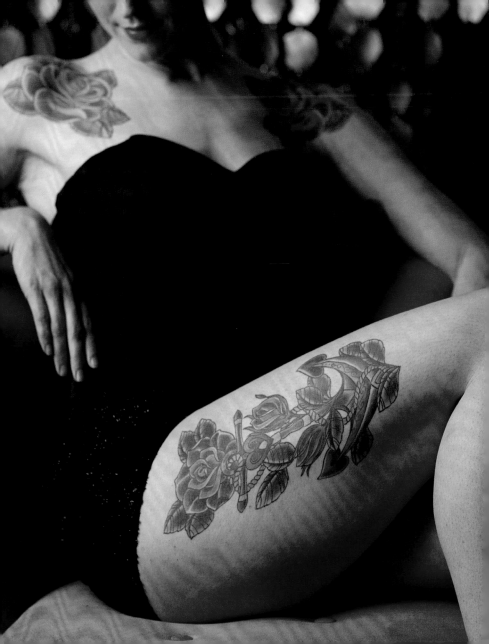

Nautical

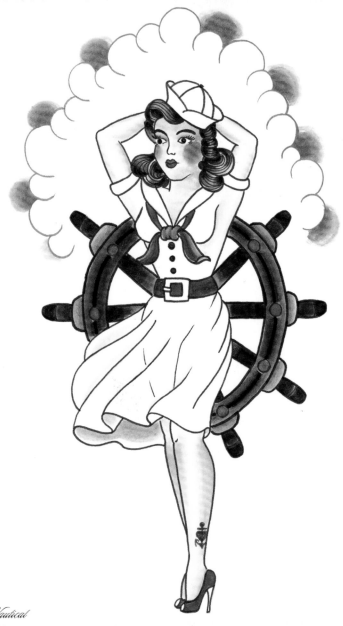

Tattooing has had a connection with the sea-faring world for centuries. The tattoo was, in fact, first brought to the Western world by Captain James Cook, whose voyages to Polynesia in the eighteenth century led him to 'tattooed savages'. He introduced the word "tattoo" (from the Tahitian tatau) into the Western vocabulary, and brought back with him the first recorded tattooed Englishman — his Science Officer, Sir Joseph Banks. Along with Banks, many of the crew on the ships also returned with tattoos, and as they continued their sailing careers, they spread the practice of tattooing around numerous European ports.

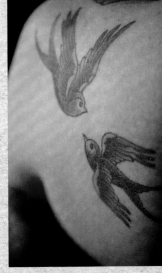

Above: Rebecca's tattoos epitomize her striking vintage style. Her roses, anchor and swallows complement one another to create an overall look. Simple, yet full of symbolism, the design of these swallows creates movement which typifies these birds that have become such distinctive icons in tattooing.

In 2008, I was lucky to work as a guest artist at Amina Charai's Brightside Tattoo in the Christianshavn area of Copenhagen in Denmark. This beautiful old port was a renowned spot for sailors to pick up a working girl and a tattoo in days gone by. As I explored the area, I noticed it was still possible to see, beneath the clean, white paint on the dockside buildings, the faint inscriptions of the old tattoo parlours which decorated the sailors for many years during the last century.

The pioneer of the traditional tattoo, Sailor Jerry was in the navy for many years. During his travels to the Polynesian Islands, he, like Captain Cook, became intrigued by the art of tribal tattoos. Unlike Cook, however, he picked up the art himself, and eventually settled in Hawaii, where he began to shape his craft, tattooing drunk sailors on stop-overs with his take on the nautical motifs they requested. As the sailors continued their journeys across the world, the tattoos went with them, making their nautical imagery a widespread trend.

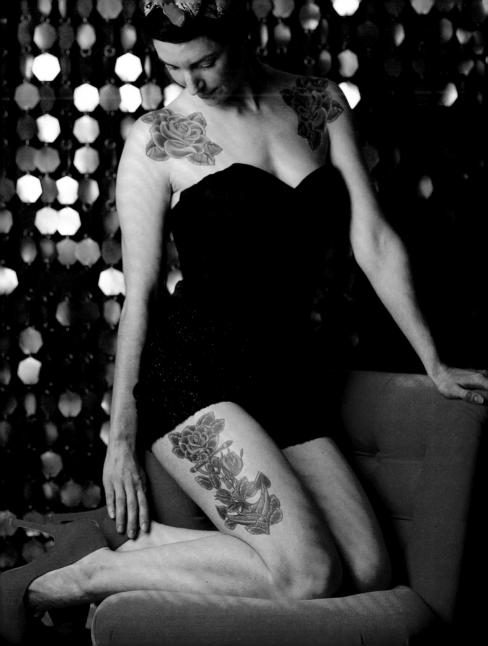

ANCHOR

The anchor is a hugely popular design which has acquired more symbolism as time has passed. Originally a motif etched onto the skin of sailors who had crossed the Atlantic safely for the first time, the anchor has come to be associated with security and safety - a depiction of feeling grounded and tied to a steady foundation. It is often tattooed to represent the feeling of being home, having found your home, or simply to signify feeling safe and assured in your life, feeling secure and solid, and happy exactly where, and as you are.

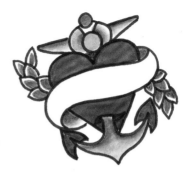

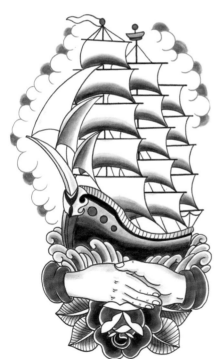

SHIP

A very popular trend among sailors in the early days of the Western traditional tattoo, the ship was used as a reminder of the sailors' home during their days in the navy. Today, just as the meaning of the anchor has changed, so has the significance of the ship. Symbolizing freedom, adventure and travel, ships are often chosen as a tattoo for individuals who have moved around and seen the world, or who feel as though they cannot be tied to one place. Visually, the vast size and strength of a ship and its ability to withstand stormy waters and difficult conditions make it an icon for those who have battled hard times and lived to tell the tale.

SWALLOW

One of the most iconic images in Western traditional tattooing, the swallow is as popular for its meaning as for its classic, simple look. Sailors would look for birds when out at sea as a sign that they were near land, and that their journey was nearly over. Swallows return to their homes every year, and so the sailors would get the swallow tattooed to symbolize good luck, and that despite what might happen on their journey, they would still make it home. Today, they are still tattooed as a good luck charm, one that will always be carried with them. Home can never be far away when there is a swallow in sight.

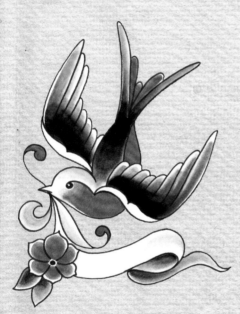

MERMAID

The legend of the mermaid is notorious throughout the world; these fantasy creatures would use their beauty to lure the sailors, who had been without female company for months, to their deaths, as they would become hypnotized and crash their ships into the rocks. Sailors would get mermaid tattoos as a warning to themselves not to blindly pursue female beauty and lose everything over it.

The meaning has become less specific over time, and the mermaid has become a reminder to men that the beauty of a woman may be enough to destroy them. For women, the mermaid tattoo can be seen to represent a woman with ultimate beauty, strength and power; the pinnacle of feminine allure.

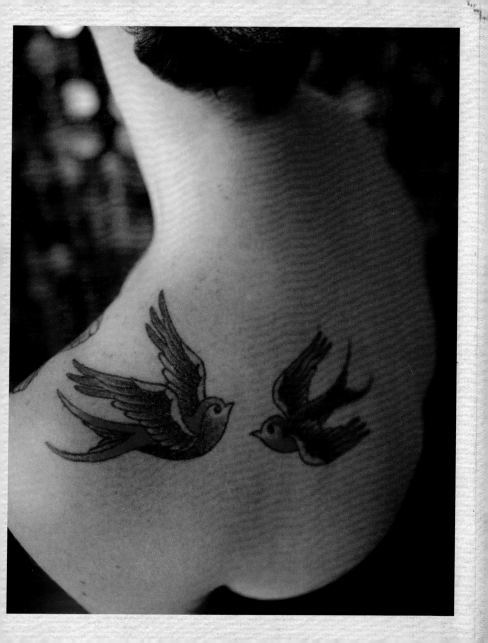

STAR AND COMPASS

The nautical star is very closely associated with the compass, as it traditionally appeared in the centre of a compass as a marker of direction. The compass is a more contemporary addition to the nautical-themed tattoo. It has a very logical meaning, in that it represents guidance and finding one's way. This can be used as a geographical emblem; a lot of people who travel or spend long periods of time away from home choose a compass or nautical star tattoo to remind them to find their way back. It can also be symbolic of finding one's way through a difficult time, a reminder that there is a path to where they need to be if they can find it.

Sailors who had an astute understanding of celestial navigation would often get a tattoo of two stars, as a mark of achievement and ability. This has become symbolic today of always feeling able to find your way, of trusting in your senses to find your direction. Many people who have experienced long periods of upheaval or travel to reach a point at which they are comfortable and happy choose to get a tattoo of two stars to mark their achievement.

HOMEWARD

BOUND

SAILOR GIRL

Tattoos of naked, nautical-style pin-up girls became hugely popular among young American men in the early 1900s, when the United States government prohibited anyone with an obscene tattoo from joining the navy. Suddenly, it was an easy way to escape the fate of having to serve – an option that many men took. In the years to come, those who had a change of heart and signed up simply found a tattooer to etch some clothes onto their obscene tattoos, and they would be free to join! These would often be sailor-style outfits to allude to the wearer's trade.

Alongside the traditional sailor pin-up, the hula girl pin-up tattoo also became very popular with American sailors, many of whom had travelled to Hawaii whilst serving. The sailors would etch the images onto them as a memory not only of their time in Hawaii, but also the memory of the women they had met – often the first women they had seen in months.

While for a time these pin-ups were deemed to be objectifying women, they have since been revived as a motif which celebrates a woman's strength and beauty, and have been adopted by many women in light of this.

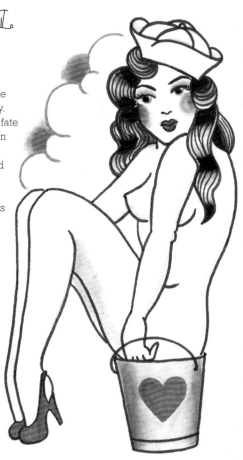

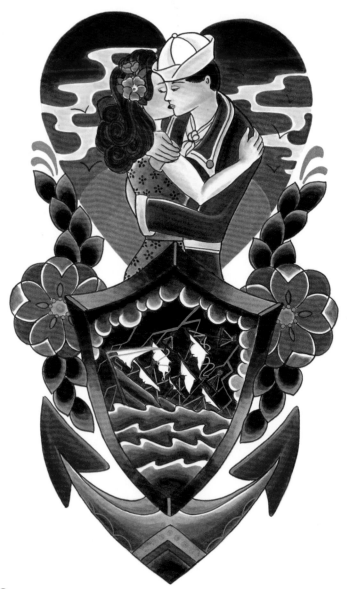

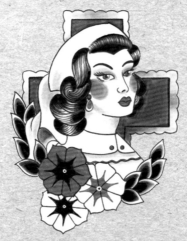

Tattoos were collected by sailors as a way of mapping on their bodies what they had done in their careers on the water; where they had travelled, who they had left behind, loves lost and family waiting, the bizarre sights they had seen and ports at which they had been entertained. Some collected symbolic and religious images to appease the storms and connect with the elements to create a sense of protection and balance with the ocean.

Today, the thinking behind nautical tattoos is very similar. They are still used as a way to map out journeys that have been taken in life, both literal and metaphorical. They can mark memories of travel, or of finding your way home, or people that have had an impact on your life. Aside from the story-telling aspect of these tattoos, the superstitious nature of those who wear them is still very much prevalent, and given that travel is such an inherent part of today's world,

the idea of wearing a mark of protection at all times may not be such a crazy concept to adopt.

Like the vintage-style tattoos, these nautical tattoos have an unmistakable air of the old-fashioned, traditional tattoos of the early twentieth century. I have often seen people choose these designs to pay homage to parents, grandparents or other relations who had originally had these tattoos in order to recreate the magic that the anchor, the swallow or the sailor girl holds for someone who had sailed the seven seas.

The lifestyle we imagine when we think of these sailors has become a part of history and these nautical tattoos allow us to feel a connection to a lost existence and show our respect to the journeys that have been taken. The associations they have with an interesting and rewarding life lived to the full makes them appealing to those who enjoy a sense of adventure.

Butterflies & Flowers

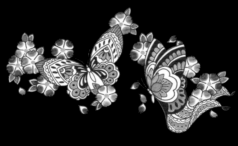

Two classic subjects in all styles of tattooing from Japanese to vintage, Chinese to mehndi, butterflies and flowers combine to create the perfect aesthetic balance in a wide range of tattoos. It is no surprise that these two natural beauties are combined so often since they are such a perfect match in nature — art which imitates nature can only produce something beautiful.

BUTTERFLIES

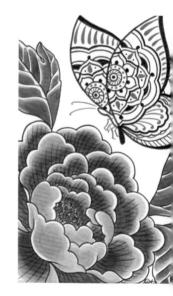

Butterflies alone have a wealth of symbolism across many cultures, which, alongside their delicate splendour, makes them ideal for the depiction of a personal message.

In mythology of many different origins, it is believed that the human soul takes the form of the butterfly. As a result, the image of the butterfly is often used to represent a free spirit, untamed and uninhibited.

In China, butterflies are symbols of happiness. The Chinese see the butterfly as a sign of long life – the Mandarin translation for butterfly means '70 Years'. During Chinese New Year festivities, butterflies are often painted onto decorations, made into kites to be flown in parades and embroidered onto celebratory clothing to create a brightly-coloured picture of joy and future happiness. And, when two butterflies are shown

together, this symbolizes a lasting love, and so this has been a motif which has been depicted at weddings in China for generations.

The Japanese see the butterfly as the embodiment of a person's soul, and as messengers that will lead you to a solution to your problems. Many believe the ancient superstition that if a butterfly lands behind the bamboo screen in your home, the person you love will visit.

In certain Indian myths, it is told that the dead go through a series of transformations in the underworld before they are reborn as butterflies, and so the butterfly is a symbol of transformation and a new start to life.

More often than not, my customers want to pair their butterflies with flowers. Just like butterflies, flowers are naturally beautiful, yet they each have their own meaning associated to them. For example, marigolds, which symbolize pain and grief, are the flowers associated with the Mexican *Dia de los Muertos* (see page 32), whereas orchids characterize a refined beauty. The iris, named for the messenger Goddess in ancient Greek mythology, is still thought to signify a message, or a good omen.

There are some flowers which are often tattooed unaccompanied, as individual pieces: roses, lotus flowers and lilies being the most popular, and I will touch on this later on in the chapter.

Of all the flowers in the world, there are two types within the art of tattooing which couple up with butterflies to create classic combinations that work together stylistically, aesthetically, historically and symbolically, and remain timeless: butterflies and blossoms, and butterflies and peonies.

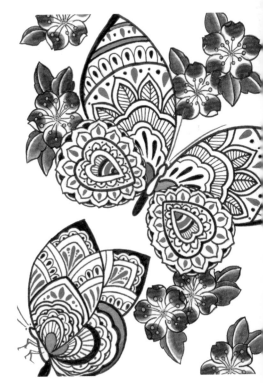

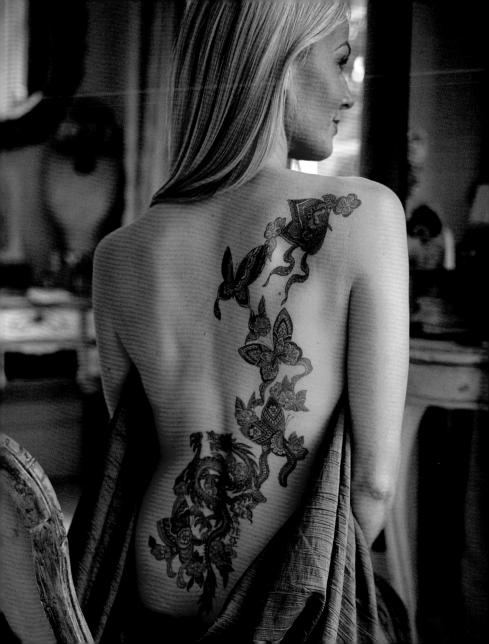

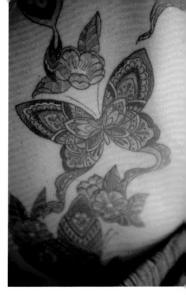

Right and far left: The design for these butterflies came from lace embroidery and mehndi patternwork, as well as the movement of Chinese butterfly illustrations.

BUTTERFLIES AND CHERRY BLOSSOMS

A Japanese classic with beautiful symbolism, butterflies and blossoms work together like no other combination, and have crossed genres and styles of tattooing to create new, interesting tattoos from humble beginnings.

Cherry blossoms are the most popular of the blossom flowers within the art of tattooing, although other types including almond blossoms, peach blossoms and apple blossoms are also not unusual, and often have a more personal significance to the wearer.

For hundreds of years, the Japanese have held the cherry blossom in awe. The flower, which blooms for just a few weeks each year, is incredibly delicate, and has come to represent how fleeting life can be. It has also come to signify change; the end of one era and the

beginning of something new. Combined with the butterfly, which represents the soul, the image created is an expressive representation of the soul within the transience of life.

From an artist's perspective, the falling blossoms, which scatter in cloud-like clusters and solitary buds - petals dripping intermittently - create the perfect surrounding for the soaring, flitting butterflies, and the feeling of movement in the image.

From a solitary butterfly surrounded by a cloud of blossoms on a wrist, to a trail of half a dozen soaring from hip to shoulder, to a full sleeve, I have tattooed hundreds of butterflies and thousands of blossoms over the years, and every one has been a completely unique design for a unique individual.

BUTTERFLIES AND PEONIES

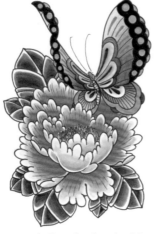

The peony is thought of as the 'king of flowers' - the symbol of good fortune in Chinese and Japanese cultures. The peony represents spring and is believed to embody romance and prosperity, often given as an offering of good fortune and a happy marriage. The peony is often depicted in bloom, with a butterfly nearby, attracted to the pollen and the bright colours of the petals, or perched daintily on the edge.

As well as the traditional Japanese depiction of the butterfly and peony within tattooing, the Chinese style is also very popular, as its decorative imagery gives unlimited opportunity to embellish the design. Years ago, a client came to

me wanting a butterfly and a peony tattooed on her side, but with a sense of movement and flight. I designed a very ornate, decorative Chinese-style butterfly, in the centre of whose wings among the patterns and the colours lay a peony. Since then, I have been asked on many occasions to hide a flower within the butterfly.

Just like the butterfly and blossom combination, peonies and butterflies can be designed in a limitless way and tattooed anywhere on anyone. The characteristic shape of the single peony and solitary butterfly as an individual piece, decorating a foot or a forearm, or multiple flowers surrounded by a kaleidoscope of butterflies filling an arm or trailing up a leg makes a bold statement on any woman: I love colour, I love beauty, I love life.

Flowers are probably the most popular subject for women who want tattoos, due to their natural grace and beauty and their symbolic meanings. There is a theory that having a flower tattoo will forever remind the holder of natural beauty. Flowers are timeless and naturally feminine, and no two are ever completely the same, so as a tattoo, they can be as unique as the possessor.

Right: Kate's bold, black patternwork looks striking with the subject it depicts; the birds, butterfly, flowers and leaves. The red peony is strong enough to not only stand out in the overall design, but add another touch of femininity to the piece.

Below: The red line-work peonies embellish Laura's sleeve, creating a border of flowers around the top of the shoulder which sit delicately, enhancing, but not overshadowing, the phoenix below.

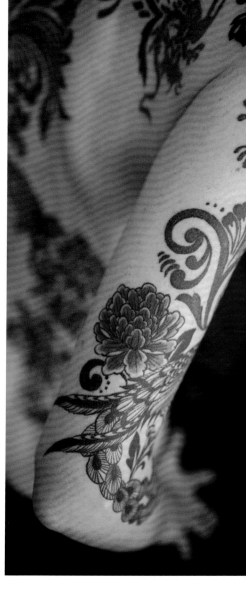

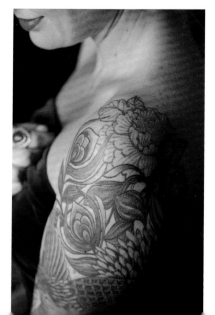

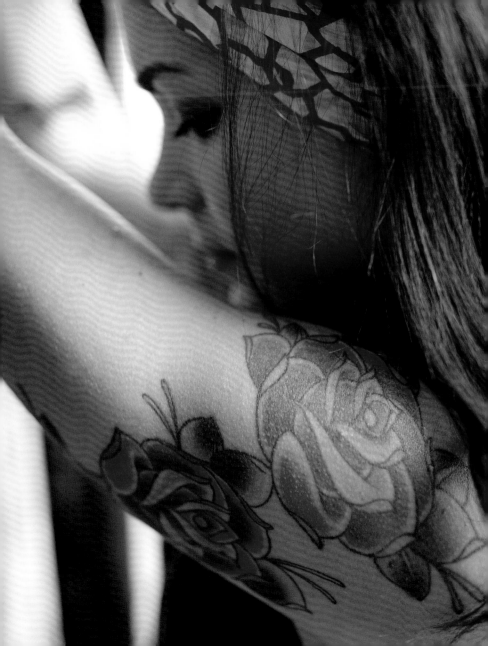

ROSE

The most traditional of all flower tattoos in the West, the rose immediately springs to mind. Beyond its most recognizable incarnation in the vintage styling of the traditional tattoo, the rose has adorned many women in many different styles.

The history of the significance of the rose is diverse, with many varying stories attributed to it throughout the centuries. The ancient Greeks believed the rose was white until the goddess of love, Aphrodite, pricked her finger on a thorn, which bled onto the petals, turning them red. Since then, the rose (particularly the red rose) has been associated with love and passion.

Different colours of roses have different meanings, however. The rose, which was a favourite motif in arts and crafts of the time, captivated the Victorians and so they assigned significance to each shade, something which has regained its importance in today's tattoos. Yellow symbolized friendship, and is often tattooed in a pair on two friends, or to mark a lost friend. A white rose denotes purity, purple represents love at first sight and black is a sign of death, darkness and loss.

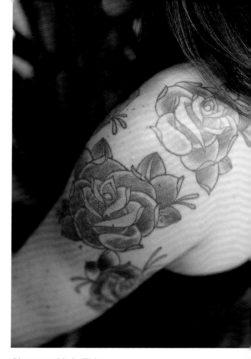

Above and left: This piece started with just a couple of roses, but it didn't take long for Tove to decide she wanted to add more. It grew organically to fit her like a sleeve should, and looks like it was designed this way from the start.

"The three roses on my shoulder was my first tattoo. I'd been planning it for about three years. I hate the term 'memorial tattoo', but in a sense, my roses were inspired by the passing of my late father. I felt a strong need to get the tattoo done after he passed, as I feel roses represent life and beauty, and I wanted to get something with a positive significance. My plan from the start was to extend the tattoo, which we did, adding a butterfly and some blossoms which trail up my back onto my neck. When we put my father's initial at the top, it felt as though the piece was complete."

Amy

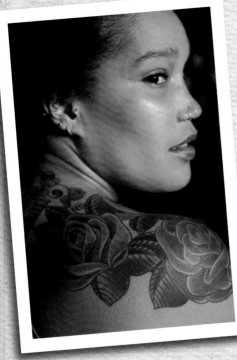

LOTUS

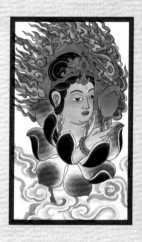

The lotus flower is an iconic image in all of the Eastern arts and particularly in tattooing. Aside from having deep religious symbolism in both Hinduism and Buddhism, the lotus is believed to have been the first flower of the universe, and so has become a symbol of rebirth all over the world. It is sometimes tattooed as a reminder of some significant change in life – a metaphorical rebirth.

The flower itself grows from mud, and rises from murky water to stand strong as a beautiful bloom, and so is seen by many to represent growth from hard times to become strong, and as a symbol of purity. A red lotus has a meaning very similar to that of a red rose, symbolizing love, passion and the heart, whereas the blue lotus means wisdom and knowledge.

CHRYSANTHEMUM

Although it is mostly found in Japanese tattooing, the crysanthemum is one flower which seems to be growing in popularity. The Chinese often identify it with the autumn, the season in which it flowers. It has taken on many meanings associated with the season and has also become representative of periods of contemplation. The crysanthemum is often gifted in congratulations and to wish for long life.

In Japan, the crysanthemum's affiliation with life and longevity comes from its solar appearance: the circular centre with long, ray-like petals streaming away from it. The sun has always been a very symbolic image in Japanese culture, and today the Japanese Imperial have the crysanthemum as their emblem, and the Japanese Emperor's title is still known as 'The Crysanthemum Throne'. The crysanthemum plays the complementary part to the cherry blossom in tattooing. While blossoms represent the transience of life, the crysanthemum depicts a full and complete life lived to the maximum.

Right: The long petals and spiralling movement of the crysanthemum makes a beautiful contrast to the gentle clouds in Sarah's sleeve – a classic combination in Japanese tattooing. I have softened the background here, using soft shading, and outlining only the flowers to make them the focal point of the design.

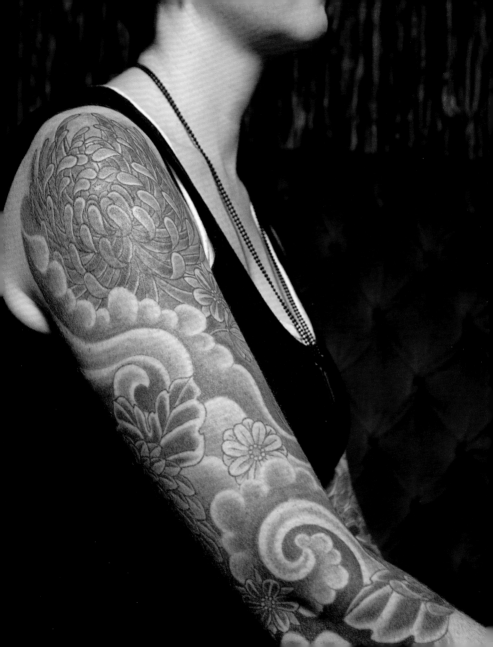

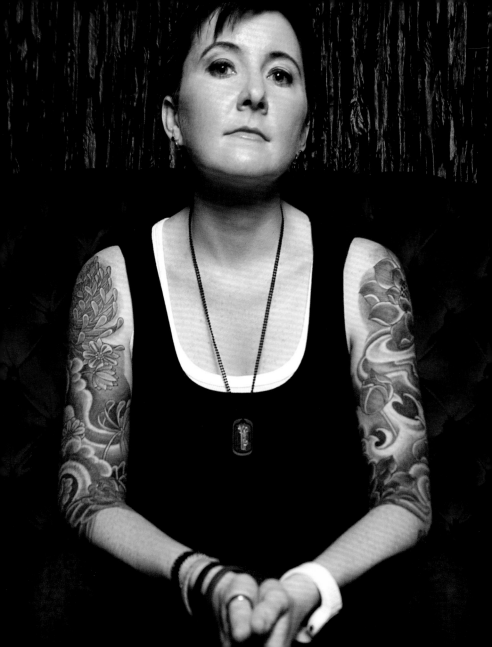

"My three-quarter sleeve on my right arm is to remember and commemorate my Mum and Dad. I chose flowers as the theme as I wanted something feminine and timeless. My idea was for black and grey with just one single colour that would highlight the part of the design which represents my parents.

"The two large red flowers symbolize my Mum and Dad, and the smaller one represents myself. When the tattoo was complete, I felt inspired to get my left arm tattooed as well, with a design that would complement and match the one on my right arm."

Sarah

LILY

The lily has ambiguous connotations as it can be depicted in numerous ways and embraced as the flower to represent several different meanings. It is largely associated with purity and innocence due to its white petals, but also because of its connection with the Virgin Mary.

It was adopted by the Christians as a symbol of Christ's resurrection, and through this has come to signify faith and the departed soul of the dead. Lilies are often depicted in memorial tattoos or, in a similar way to the lotus flower, to symbolise a metaphorical rebirth or the end of an era.

In stark contrast to this, the lily was believed to be a symbol of fertility for the ancient Greeks and Egyptians. The French continued with this philosophy, creating the national coat of arms from the fleur-de-lis in the twelfth century due to the belief that the flower would assist the continuation of the royal line.

The lily is a strongly feminine flower, symbolic of beauty, innocence, purity and sexuality, embodying many aspects of femininity and making it the tattoo of choice for strong, self-assured women.

CAMELLIA

The camellia is one of my favourite flowers to tattoo, and one that is becoming more popular. I often suggest them to my clients as alternatives to the traditional peonies or roses, as they are similar in meaning but have a beautiful softness and shape which transcends any one specific tattoo style. The camellia is a symbol of desire and passion, but also sophistication. It is also thought to signify perfection and flawlessness.

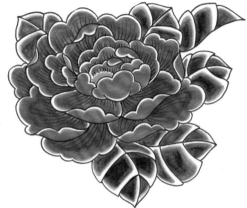

The flower as decoration dates back centuries, from ancient Egypt where lotuses adorned statues, through to Chinese vases and embroidery, Catholic ornamentation and Victorian floral arrangements. Van Gogh and Monet painted flowers, taking their natural beauty and recreating something as beautiful from them. The floral tattoo is just an extension of this concept – a contemporary take on the idea of embellishing what you have with something beautiful.

When I look back over the tattoos I have done for my female clients, there is rarely a piece that does not have flowers integrated into the design. While I find that just as many men as women will have flowers tattooed, particularly in Japanese and traditional styles where crysanthemums, lotus, peonies, blossoms and roses are frequently depicted, there is no doubt that for women, adding flowers to a piece makes it instantly more feminine.

In the majority of designs, the flower is there for purely aesthetic reasons but flowers can also add a sense of context, of scenery or background. For example, a design showing a lone peacock looks elegant, but a peacock surrounded by peonies places it in a tranquil and vibrant setting.

"My late Grandmother, Margaret, was an artist, and a great inspiration to me. I spent summers as a child with her, and we filled rainy days sitting and painting. I learned to draw and paint flowers at her house, as it was always filled with beautiful flowers. Every year, my Grandmother would frame her favourite painting I had done and hang it on the wall. Once I began tattooing, my Grandmother was delighted that I had made a career out of my art, and often expressed how proud she was of what I was doing, and that she had played an important role in my artistic talents from a young age. This peony and sparrow is the last painting I did for my Grandmother before she passed away." Dominique

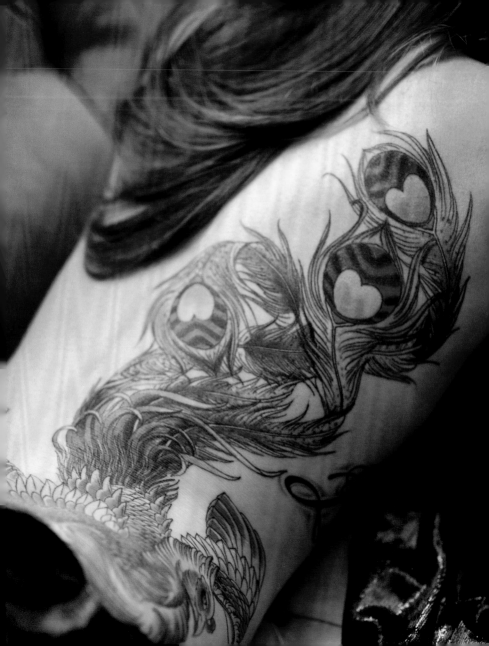

Japanese

In Japan, tattooing is known as *Irezumi*, meaning to insert ink under the skin. It can be traced back to the Yayoi period c. 300 BC – 300 AD where the first records of tattoo designs discovered on natives were thought to have spiritual significance, as well as being an indication of the individual's high status.

In the years to follow, tattoos began to develop negative connotations as they were used to mark criminals to warn others of their past crimes.

It was during the Edo period, 1600–1868, that the type of tattooing that we recognize today began to develop.

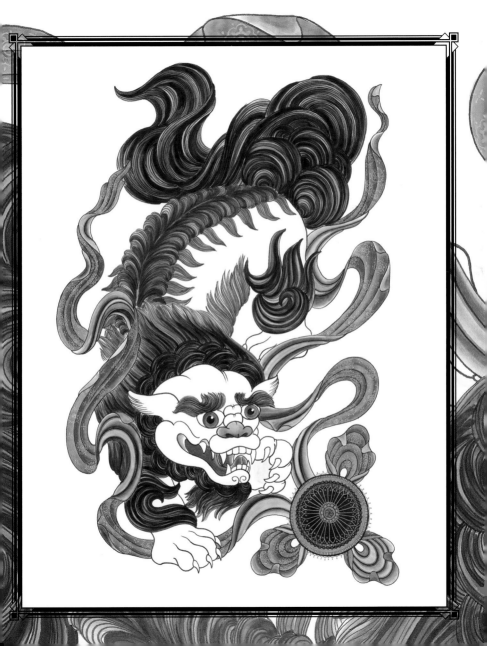

The art of woodblock printing, or *Ukiyo-e*, first appeared in the seventeenth century in Japan. The influence of this iconic style of artwork on tattooing became obvious when the Chinese novel *Suikoden* was published, illustrated with woodblock prints depicting brave men decorated with tattoos of mythical animals, flowers and religious scenes. Demand for tattoos as seen in the illustrations was instant, and it is believed that woodblock artists began tattooing, using their tools to create these early tattoos.

According to popular belief, tattoos at the time were worn by the wealthy, who were banned from parading their wealth in public, and so they wore these expensive tattoos beneath their clothes.

It was also around this time that firemen began to be tattooed with images of dragons, which were spiritually linked with water, as protection in the face of danger.

The recent history of tattooing in Japan, however, is much more fraught with controversy and negative connotations. The Japanese government of the Meiji period outlawed tattoos in an attempt to improve the nation's image with the West, and so tattooing once again took on criminal overtones. By this time, the Western world had grown fascinated with *Irezumi*, and foreigners travelled to Japan in search of these skilled tattoo artists. This meant that, in order to continue the tradition, tattooing in Japan was forced to go underground.

Although legalized by the occupation forces in 1948, tattooing has since been unable to throw off its association with the criminal underworld as it is still very much connected with the *Yakuza* (Japan's mafia), so many public businesses such as hot springs and public baths strictly forbid customers with tattoos.

Traditional *Irezumi* is still carried out by specialist artists today, although Western tattoo styles are now more popular with the youth of Japan as they have less controversial connotations. However, the Japanese style has become a worldwide artform, as its popularity continues to·grow throughout the rest of the world.

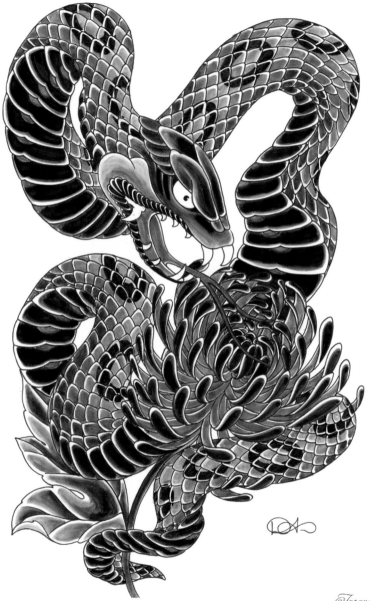

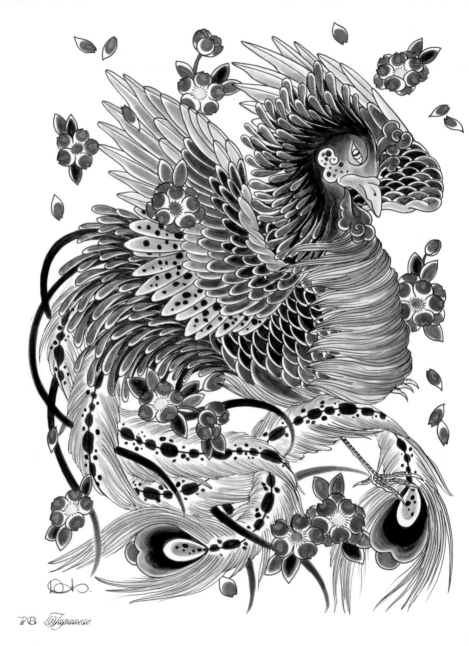

Japanese tattooing has recently become a lot more popular with women. While many stories may suggest that Japanese prostitutes collected tattoos to entice men with their exotic decoration, it is also believed that geishas adorned their bodies with tattoos as well, enhancing their appearance as figures of beauty.

Once considered a very masculine style with its heavy background and symbols of strength, it has developed a more feminine feel over the years. The versatility of the composition in contemporary Japanese tattoos has also made it more accessible. From a traditional *Shichibu* - a sleeve design measuring seven tenths of the way down the arm, depicting a dragon surrounded by falling maple leaves; or a *Nukibori* - a back piece showing a phoenix taking flight through blooming crysanthemums; to a more modern, loose arrangement of two koi swimming through lotus flowers up the side of the thigh; or a scattering of cherry blossoms trailing delicately from the ankle onto the foot; the characteristics of the Japanese tattoo can be beautifully manipulated to suit anyone, on any part of the body.

It is undisputable that one of the main reasons Japanese tattooing is so popular is that there is so much meaning behind the imagery. Each subject has a great significance to the wearer, and the design can be composed to tell the

exact story the possessor of the tattoo wishes to tell - from a single subject to a complete narrative.

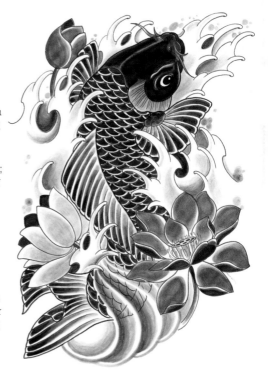

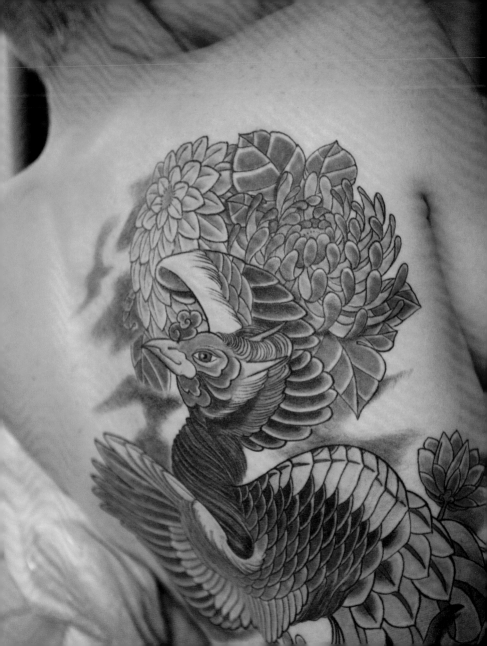

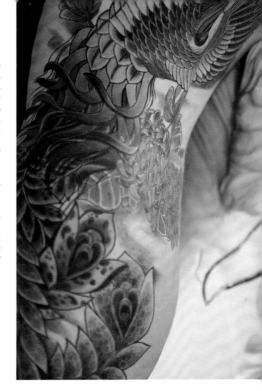

Facing page and right: This stunning back piece is the result of more than 30 hours work, not to mention the initial research, sketches and designs. A complex piece like Cecilia's takes dedication from both the artist and the client, but on completion, the finished work makes it all worthwhile.

PHOENIX

The phoenix is a hugely symbolic image that has strong, positive connotations. While it appears in many cultural references all over the world, it is strongly associated with traditional Japanese-style tattooing. The phoenix is widely revered as an image of rebirth and symbolizes a fresh start for many people. It is also associated with longevity and prosperity, elegance and true virtue. The phoenix is a very popular image for women on account of its beauty, strength and grace.

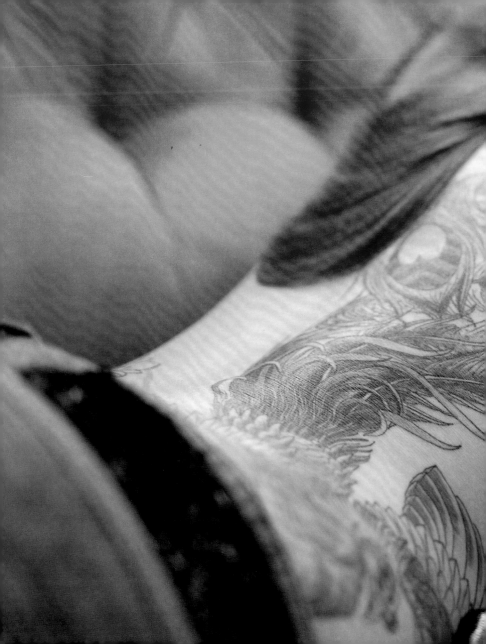

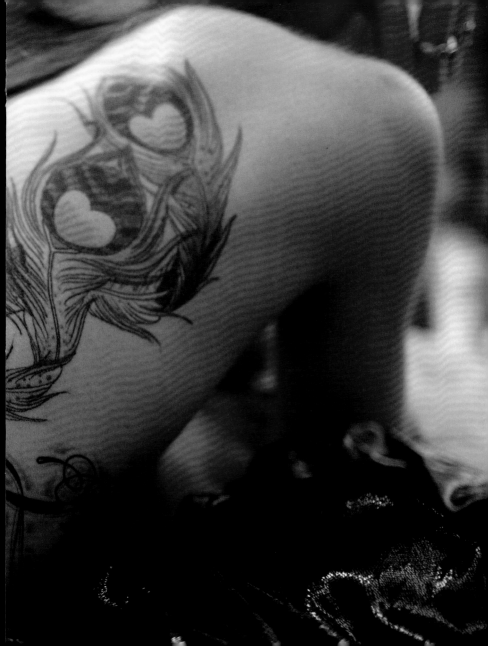

"I always knew I wanted to go big with my back tattoo and felt I needed something feminine and graceful because I didn't want it to come across as aggressive.

There are many myths defining the symbolism of the phoenix so I didn't want a traditional 'fiery' phoenix. For me the importance was in the beauty and strength of the bird.

"I think all women struggle with their self esteem now and then and there is always something we would like to change about our bodies.

"Having my tattoos has changed my body image and I look at myself more positively as a result. There is so much influence from the media telling us how we should look and for me it's a liberating feeling that I can actually look the way I want to and be proud of it regardless of whether other people approve or not. Tattoos are very personal and you are the only one who can really know what you want."

Cecilia

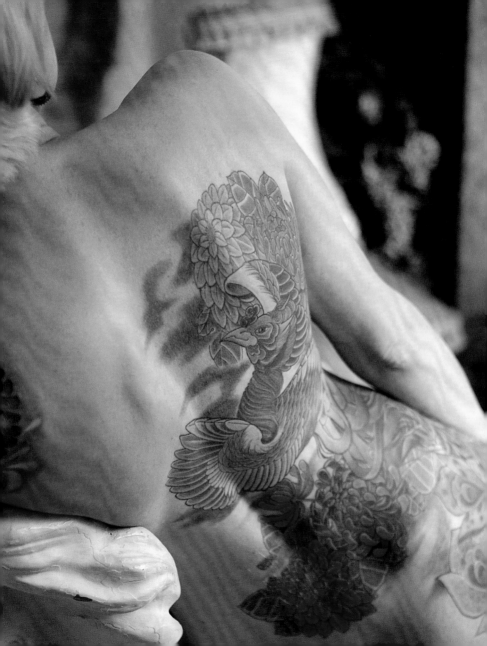

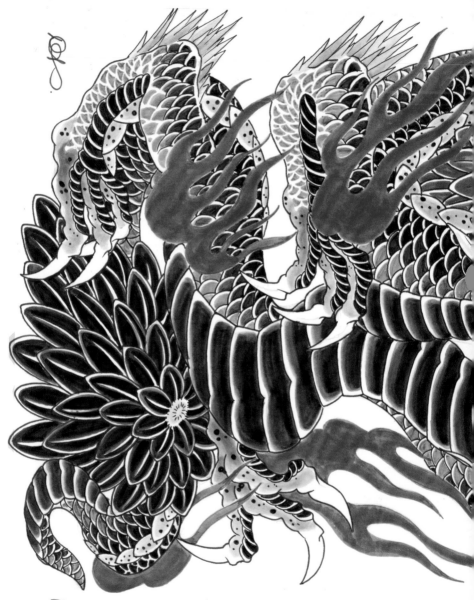

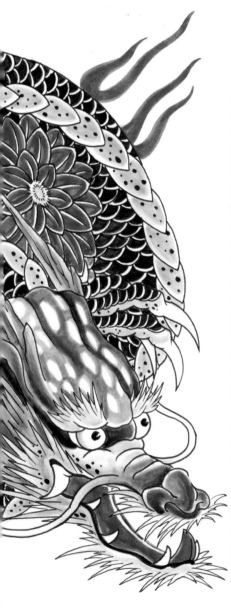

DRAGON

Contrary to Western depictions of dragons, their Asian counterparts are not necessarily regarded as evil beings, and are usually benevolent symbols of good luck. Indian mythology recounts the origin of the dragon as a deified snake, which became steadfast in Japanese legend. Japanese dragons are symbols of power and knowledge, wisdom and skill. They are viewed as good luck omens, as they are seen to offer spiritual and physical protection over the wearer.

The dragon is believed to live for hundreds of years, and the mythological creature is shown combining the characteristics of animals it encounters throughout its long life. It is often depicted with the head of a camel and a hump which allows it to fly, the ears of a cow, the horns of a stag, the belly of a snake and the scales of a koi carp. The claws are those of a hawk, and the eyes are either of a rabbit or a demon. The legend goes that the dragon's voice sounds like the musical ringing of a copper bell, and its breath smells perfumed.

There are several types of Japanese dragon, all of which have different meanings in tattooing, for example, *Han-Riu* represents strength whereas *Fuku-Ryu* is considered the good-luck dragon, believed to bring good fortune and prosperity.

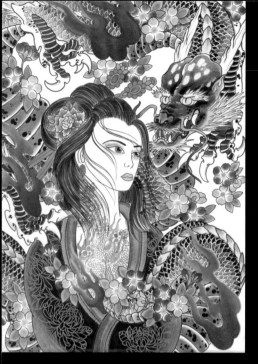

GEISHA

The geisha is often wrongly believed by the Western world to be a prostitute, when actually she represents the ideal female qualities. The geisha symbolizes beauty, calm and patience, and tattoos of the geisha are meant to signify this.

It is believed that geishas may have been among the first women in Japan to be tattooed which also makes this a very nostalgic tattoo to choose.

In the same way as the gypsy girl or the pin-up depicts a type of female beauty, so does the geisha, but with an added sense of grace and peace. I find that the geisha is often tattooed simply to depict beauty.

"I got the idea for this painting when I was working on a design for a customer who wanted a half-sleeve tattoo showing a geisha and a dragon together. Dragons are so often chosen as a tattoo thanks to their protective significance, and I began to imagine them coming to life to create a living armour around the wearer.

The painting shows the geisha, confident that her dragon tattoo offers her a sense of everlasting protection and good fortune, representing a feeling shared by so many of the tattooed kinship."

Dominique

TIGER

For many years, the tiger was virtually a mythical beast to the Japanese. Their early knowledge of the animal came solely from Chinese writings and art. The tiger originated in China, where it was revered as one of the four guardian animals of Chinese astrology.

In Japanese tattooing, the tiger symbolizes strength, courage and beauty. It represents a natural wildness and an unwillingness to be tamed.

The tiger has become a popular subject within many other styles and genres of tattooing, such as Tibetan and Chinese styles, Western traditional, tribal and realist - its symbolism crossing many style boundaries.

MAPLE LEAVES

Maple leaves have two main meanings within Japanese tattoos. They are a symbol of passing time, as they represent the changing seasons, which in turn signifies the cycle of life and death of all living things. These leaves are often used in the background of a piece with a central image of a water snake, a dragon or a goddess, for example. They are used to represent the wind as they are usually depicted floating through the air or water.

In Japan, the maple leaf is also often given as a Valentine's gift. It is a symbol of love and desire, comparable to the rose in Western culture. Maple leaves share this meaning when tattooed, and can be seen floating over the shoulders of lovers, or falling around a geisha.

KOI CARP

One of the most popular of the Japanese motifs in the West today, the koi carp, is instantly recognizable. It is popular because of its meaning, and because its meaning can be interpreted in different ways simply by altering its design. The koi symbolizes courage, and overcoming of a difficult time in life.

A koi depicted swimming upstream represents a current battle the wearer is experiencing, whereas swimming downstream signifies the triumph over a difficulty or an obstacle in life.

The colour of the koi also has a deep meaning: a red koi symbolizes love, a black koi represents a new direction to be taken in life and a gold koi characterizes success and wealth.

In tattooing, the koi are often depicted swimming through lotus flowers, as the symbolism of both these images runs closely alongside each other since the lotus has already overcome hardships to bloom into life above the murky pond, adding even greater optimism to the piece.

DRAGON KOI

The story of the dragon koi is one that stands for courage, determination and perseverance. Legend has it that the koi swims upstream to the Yellow River waterfall, also known as the Dragon Gate. If it can cross the waterfall, it transforms into a dragon. It is a symbol that nothing is impossible if you have faith that you can get through the obstacles that are in front of you, and if you do, you will reap your reward.

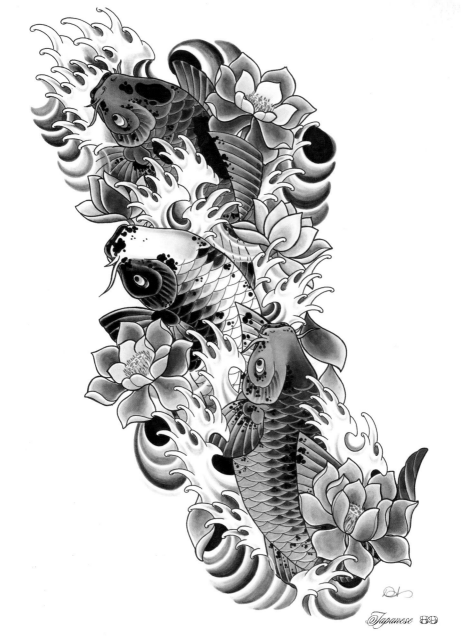

Japanese 89

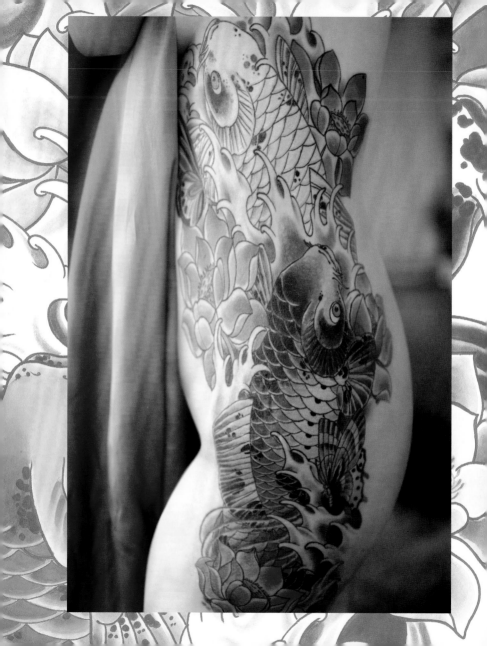

"This design came about from a painting I did while designing a sleeve for my boyfriend. He wanted a classic black, grey and red Japanese design but I decided instead to elaborate the piece with colour. Having framed and hung the painting in my studio, my customer Lissa took one look at the painting, and it was all the inspiration she needed for her tattoo. From there, I took two of the koi and the lotus flowers, added two butterflies to create a slightly more feminine image, and Lissa's design was complete."

Dominique

The most popular imagery within Japanese tattooing has been around as far back as the *ukiyo-e* woodblock prints of the seventeenth century. It is still as relevant in its meaning today as it was back then, and such timeless symbolism makes the tattoos of the style perfect to choose as a lifelong image.

In traditional Japanese tattooing, there are set rules of design that an artist needs to follow. While these can be interpreted by the individual and manipulated into completely unique compositions, I find they can sometimes feel a little restrictive.

When it comes to painting Japanese imagery on canvas, I find a much greater sense of freedom as I feel more comfortable leaving these rules to one side. Painting my Japanese-influenced artworks takes me closer to the old woodblock prints of the Edo period.

Ukiyo-e has long influenced many important visual artists outside of tattooing. In 1890, an exhibition of Japanese prints was held at L'Ecole des Beaux-Arts in Paris, which is believed to have been a catalyst in the innovation of the Art Nouveau movement. However, a stream of artists including Vincent Van Gogh, Edgar Degas, Henri de Toulouse-Lautrec and Mary Cassatt were already creating works inspired by the *ukiyo-e* style and imagery. While the technique of woodcutting was not employed by these artists, the stylistic signatures of decorative pattern, bold but flat colours and strong lines were unmistakable and these characteristics translate very well into tattooing.

While my Japanese-style paintings are perceived to have been influenced by the aesthetics of tattooing, to me they are, in fact, more influenced by *ukiyo-e*.

As an artist, I found myself drawn to the Japanese style for two main reasons. The aesthetic qualities of the print-like imagery, the bold colours and strong graphic background drew me in, but I also found the characteristic personalities of the subjects, the suggestive mood created by the elements in the background and the complete scene created by a few simple images very appealing. I found I became even more attracted to the style as I learnt more about the intrinsic mythology within the culture and the way it is depicted using simple forms.

JAPANESE MYTHOLOGY

Japanese mythology is vast and inspiring, as it incorporates folk tales alongside Buddhist and Shinto traditions. Its subjects include everything in Japan's history, from the creation of the land to the numerous spiritual deities, as well as mythological and real creatures. The stories are so beautifully balanced between realism and a magical fiction that they make the perfect subjects for painting, design and obviously tattooing as well. Some of the myths have become popular motifs within tattooing: Raijin, the god of thunder, is often depicted beating drums alongside Fujin, the god of wind, who carries a bag on his shoulder from which the gusts emanate; Kitsune, the nine-tailed fox, and Fu-Dogs (also known as Fu-Lion or Lion of Buddha) are becoming much more prevalent in tattooing today. Others are more obscure, but just as beautiful. However, I find it is the tales of the goddesses, geishas and demonized ladies of Japanese history which most appeal to my creative mind.

BENTEN

Benten is one of the seven gods of luck and is revered in Japan as the goddess of love, eloquence, learning, music and the fine arts. She dates back over 1000 years. The story goes that she lured a dragon that was destroying the land out to the island of Enoshima, where she hypnotized it, sending it to sleep with the sound of her magical koto, before killing it and saving Japan from devastation. A temple was built on the island to honour her.

Many centuries later, the notorious warlord Hojo no Tokimasa prayed to her, asking for her to bring prosperity to his family, and when the image of Benten appeared before him, he noticed that the lower half of her body had become that of a dragon.

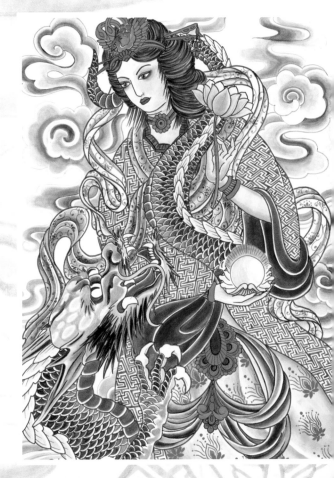

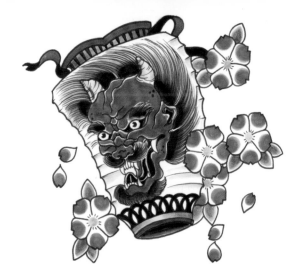

KIYOHIME AND ANCHIN

The origin of the Hannya mask, a popular motif in Japanese tattooing, comes from an ancient Noh play, *Dojoji*, which dates back to around 1000AD. Kiyohime was the daughter of a wealthy steward named Shoji who lived on the Hidaka riverbank. The family would provide lodgings to priests who would pass by on their way to visit the shrine of Kumano. One day, a handsome priest from the northern provinces, Anchin, visited on his way to worship. Kiyohime fell in love with him, and from then on, Anchin would return every year, bringing her gifts. After a few years, his feelings for Kiyohime began to fade, and he spurned her affections. Overcome by his rejection, Kiyohime pursued him in a fit of rage, chasing him

down to the Hidaka river. Anchin found a boatman to take him across the river, and made him promise not to let Kiyohime cross. Seeing that her love was escaping from her, Kiyohime dived into the water and tried to swim after him, but she became caught in the torrent, and, in her intense rage, transformed herself into a serpent. Anchin saw the transformation and scurried into the temple, *Dojoji*, where the priests helped to hide him beneath the temple's bell. Unfortunately for Anchin, the serpent of Kiyohime could smell him hiding and coiled itself around the bell, ringing it loudly before exhaling a ball of fire. The serpent's fire melted the bell, killing Anchin instantly.

The Hannya mask was created for the play to represent the transformation of the once-beautiful woman into a crazy, jealous, rage-filled demon. With gold fangs protruding from its contorted mouth, and sharp horns from the temples, the mask is often coloured a deep shade of red to signify intense anger. Traditional Japanese wedding dress is thought to include a headdress to hide the horns, and often the Hannya is tattooed with a veil concealing part of them. Whilst there are some other theories behind the origin of the name Hannya, the most credible story is that it comes from one of the original carvers of the masks in the fifteenth century, an engraver by the name of Hannyabo.

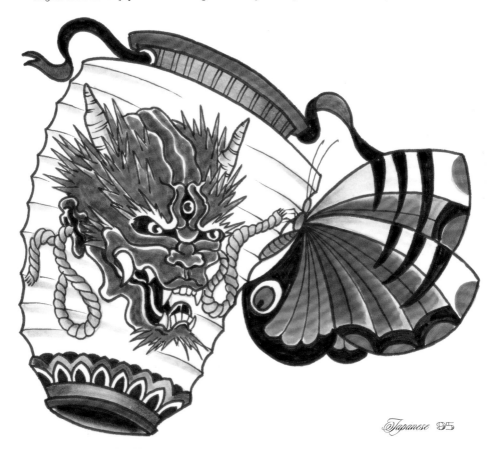

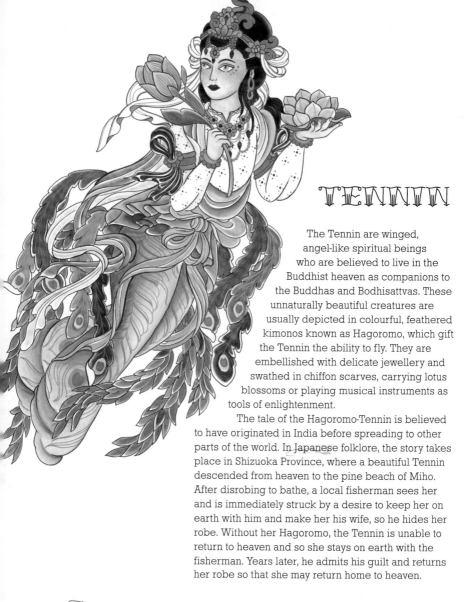

TENNIN

The Tennin are winged,
angel-like spiritual beings
who are believed to live in the
Buddhist heaven as companions to
the Buddhas and Bodhisattvas. These
unnaturally beautiful creatures are
usually depicted in colourful, feathered
kimonos known as Hagoromo, which gift
the Tennin the ability to fly. They are
embellished with delicate jewellery and
swathed in chiffon scarves, carrying lotus
blossoms or playing musical instruments as
tools of enlightenment.

The tale of the Hagoromo-Tennin is believed
to have originated in India before spreading to other
parts of the world. In Japanese folklore, the story takes
place in Shizuoka Province, where a beautiful Tennin
descended from heaven to the pine beach of Miho.
After disrobing to bathe, a local fisherman sees her
and is immediately struck by a desire to keep her on
earth with him and make her his wife, so he hides her
robe. Without her Hagoromo, the Tennin is unable to
return to heaven and so she stays on earth with the
fisherman. Years later, he admits his guilt and returns
her robe so that she may return home to heaven.

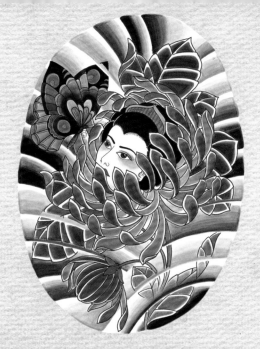

"The Namakubi-Kuri painting marked my fifth anniversary
at The Family Business Tattoo Parlour. The severed head,
or Namakubi, is often used as a symbol of accepting one's
fate graciously. Instead of the traditional samurai, I
chose a geisha's head to symbolize the calm and patience
I have needed to succeed in my art. I used the Namakubi
to represent that I have been successful but I will never
take for granted what I have achieved. The crysanthemum
portrays my hope for longevity in life while the open
flower is used to acknowledge that my decade in tattooing
has been fulfilling. The butterfly symbolizes my free
spirit which initially drew me to the art of tattooing."

Dominique

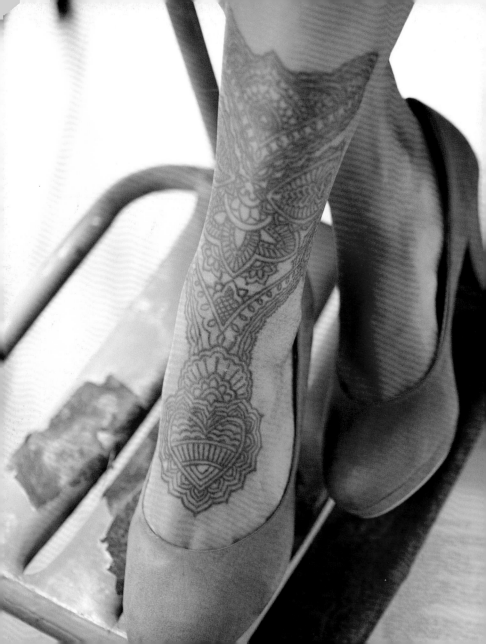

Mehndi

Of all the styles of tattooing I work with, the mehndi designs are probably the most decorative. The ancient art of mehndi can be traced back through many different cultures over the past 5000 years, originating in ancient India. Over the centuries, the trend spread across Pakistan, Nepal, Bangladesh, then further afield across the Middle East and Africa. Over the past century in particular, the ever-growing expatriate communities in the UK and America have seen the mehndi style become commonplace in the West.

In Indian and Pakistani culture, mehndi is seen as a ceremonial art form. It is believed that its original purpose was to symbolize the outer and inner sun, from the early Vedic traditions which centered around the 'awakening of the inner light'. Many of the traditional Indian mehndi designs were depictions of the sun positioned on the palm of the hand. It is often mistakenly referred to as 'henna' – the type of ink with which the Mehndi patterns are applied onto the skin.

The intricate patterns, composed of fine lines and repeating motifs, are traditionally used to decorate the hands and feet of the bride for her wedding, and the ritual of the application of the henna ink before the ceremony is in itself a celebrated tradition for the family. The designs are so intricately detailed, it is not unusual for the groom's name or initials to be hidden within the patternwork. In some regions, such as Rajasthan, it is also customary for the bridegroom to be decorated with patternwork similar to that of his bride, but other than in these occasional appearances, it is very much adornment just for women.

Mehndi decoration within Muslim culture is often used to mark the coming of age. In parts of the Middle East, it is also part of the wedding ritual, where the night before the wedding is dedicated to the mehndi, and referred to as the 'henna night', as well as being applied during Eid celebrations, and other family festivities.

Regardless of which of its many cultural traditions the mehndi is applied, it is always seen as a way to adorn the woman. In the same way that a woman's wedding dress will be perfectly tailored to be the most exceptionally stunning clothing she has ever worn, the mehndi must be equally beautiful. The mehndi is like jewellery for the skin, and a celebration of female beauty, so the most important element of the design is that it is the perfect decoration.

It is not just the tradition that differs in each region. The style itself has certain characteristics associated with the different cultures and influences.

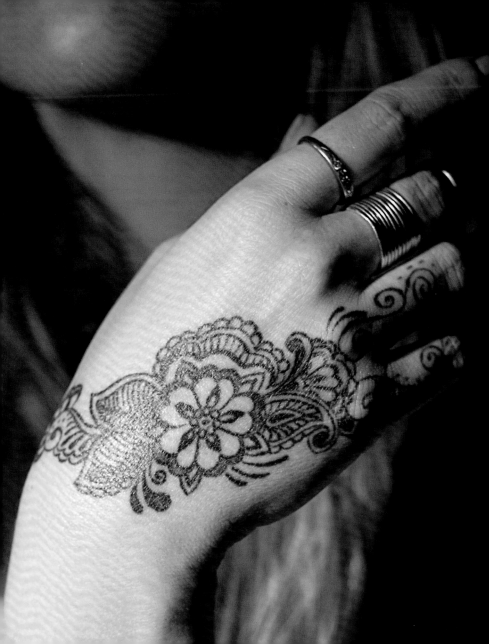

Left: To capture the movement of the hand and ensure it fit perfectly, I drew Sarah's Indian-inspired Mehndi tattoo straight from my original design onto her skin.

ARABIC

Arabic mehndi is usually less intricate in design than its more Eastern equivalent. Vines, leaves and flowers feature heavily, and typically the style has more solid areas and less detailed fill-ins. The Arabic designs are not limited to the hands and feet, but designed to fit any part of the body, which has seen them so easily translated into the contemporary tattoo style we see so often today.

INDIAN

Traditional Indian mehndi is very linear, with lots of repeating patterns, often with a focal point on the palm to represent the sun. The designs often feature Mankolam (the Tamil name for paisley) motifs, which have been used in Indian design for centuries, and have a correlation with Hinduism.

PAKISTANI

Pakistani mehndi has the most detailed and complex fine lines and fill-ins. These styles tend to be created for hands, arms and feet, particularly for wedding celebrations.

"The mehndi design on my foot is the most spontaneous of all my tattoos, and it has no deeper meaning than a love for this style of design. It was only a few months after my first tattoo, but I had become obsessed with the Hindu henna patternwork designs. I love the shapes that the patterns create, and thought that the curves of the foot and form of the leg would complement the mehndi style."

"My tattoos symbolize stages in my life and my love of art and design. I draw inspiration from all different cultures, and I find the way people interpret art differently both fascinating and beautiful. My tattoos help me to express myself and visually create in a way no other medium can."

Amy

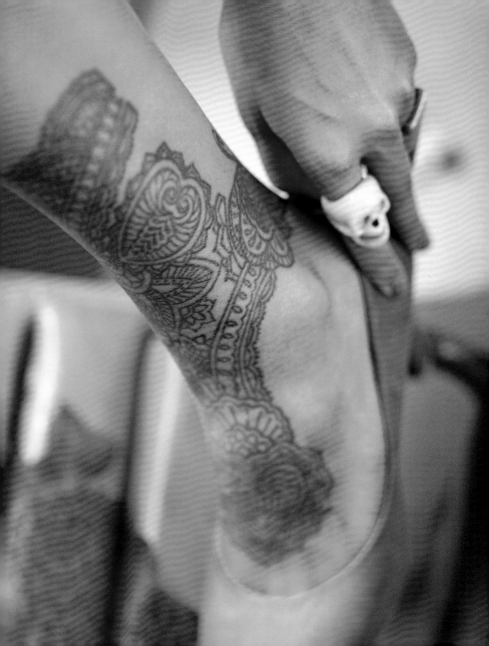

The mehndi-influenced tattoos I do today are a true illustration of how the different styles of the art form have evolved over the years. Travel, migration, cultural diversity and interaction have all had a hand in the merging of styles, not least in this genre. When I design mehndi-style patterns, I take influence from Indian, Pakistani and Arabic Mehndi in equal parts, but when I create specific designs for my customers, I tend to listen to what they would like aesthetically, and then work a style around that. I can usually tell immediately if they are drawn to the more intricate Indian shapes, or the flowing Arabic style of work.

I have tattooed some women of Indian or Middle-Eastern descent who want mehndi pieces to denote their cultural heritage and in those cases I have worked to ensure that their culture's style is recognizable in their design.

I find that people are drawn to this particular type of tattooing, regardless of their background, because of its delicacy and ornamentation. Mehndi does not fill the body in the way that a traditional tattoo or a solid black tribal band would; instead it sits daintily on the body, its lace-like quality giving it a sheer appearance of soft decoration. It has a mysterious quality to it which hints at exotic influences and ancient traditions. Mehndi pieces do not necessarily seem the most obvious

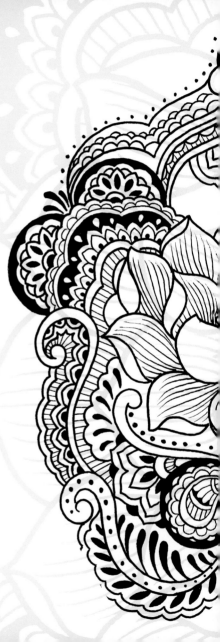

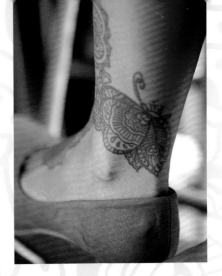

choice for a tattoo, as they're considered pure decoration. My customers tell me that people are often shocked to discover they are real, permanent tattoos, as they assume that these designs are inked on the traditional henna technique.

Above: This piece on Amy's leg and foot is the tattoo which really ignited my passion for mehndi patternwork. It was the first time I created my signature butterflies in the mehndi style.

Having always been drawn to intricate detail and linear patterns, my interest in mehndi stems from its visual qualities. While so many images within my art and tattooing hold a deep symbolism, the sole purpose of mehndi is to decorate and embellish – something which I feel holds no less significance. There is almost a sense of condescension with many people, especially outsiders to tattooing, that a tattoo without a significant meaning is not quite as tolerable, or acceptable, as one that holds great symbolism. A tattoo for the sake of a tattoo should not be held with any less regard, just as art does not necessarily have to be greatly symbolic to be admired. I sometimes feel as though mehndi could be considered the jewellery of tattooing.

In a similar way to tattooing, mehndi is still not fully appreciated for the art form it truly is, often dismissed as meaningless decoration or a wedding accessory – a craft more than an art.

With my tattoo designs and in my artwork, I love to push the boundaries of different styles and use mehndi to embellish my images further; a painted henna-style decoration on the hands of a female figure, a Mandala as a 'halo' effect arching over the top of the subject, embroidered into the clothing or the scarves of a goddess or a gyspy, or even as a background pattern.

The slightest suggestion of mehndi pattern within a design can bring a different feel to the image, as its strong Eastern appearance can create a sense of the exotic and mysterious.

I often like to use the mehndi design style to depict images with a deeper meaning, creating a kind of juxtaposition within the style. While the patterns and shapes we generally associate with henna tattooing revolve around the importance of decoration, mehndi can be designed to depict images with great significance attached to them. The peacock, for example, is the national bird of India; butterflies are a symbol of life and the soul; lotus flowers or a phoenix are both representations of rebirth, and although the mehndi style gives these a more ornamental appearance, the significance of the subjects is no less prominent. I feel as though creating these sorts of artworks can demonstrate that mehndi should not be overlooked as a fine art in itself, nor should it be regarded simply as an old Asian ritual.

In a time when Indian and Pakistani cultures are rapidly integrating within the Western world, their exquisite artistic and decorative traditions are a welcome addition to our own.

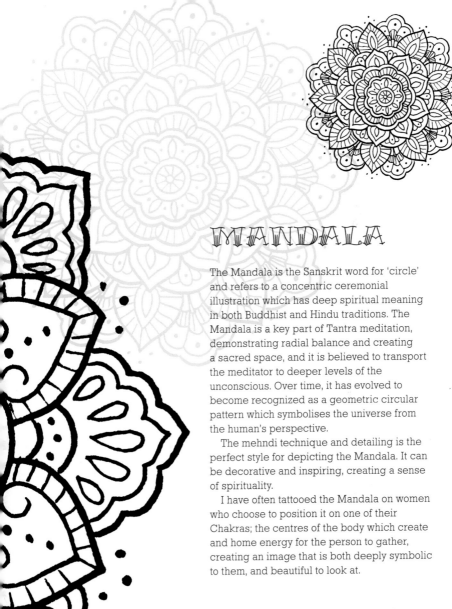

MANDALA

The Mandala is the Sanskrit word for 'circle' and refers to a concentric ceremonial illustration which has deep spiritual meaning in both Buddhist and Hindu traditions. The Mandala is a key part of Tantra meditation, demonstrating radial balance and creating a sacred space, and it is believed to transport the meditator to deeper levels of the unconscious. Over time, it has evolved to become recognized as a geometric circular pattern which symbolises the universe from the human's perspective.

The mehndi technique and detailing is the perfect style for depicting the Mandala. It can be decorative and inspiring, creating a sense of spirituality.

I have often tattooed the Mandala on women who choose to position it on one of their Chakras; the centres of the body which create and home energy for the person to gather, creating an image that is both deeply symbolic to them, and beautiful to look at.

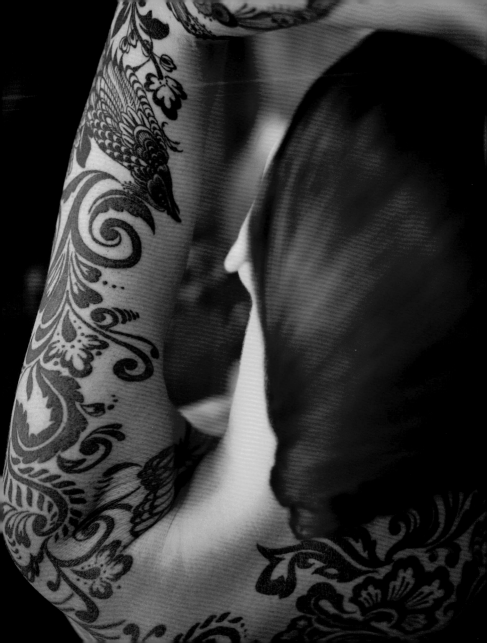

Fusion

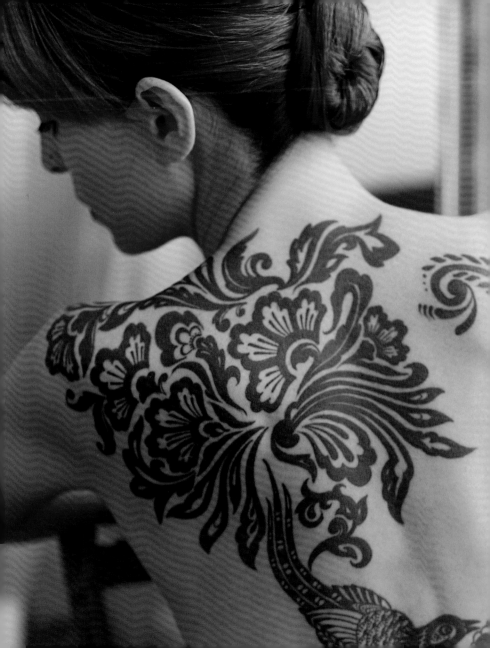

Left: Black-work tattoos have been given a new lease of life with fresh approaches to design, more intricacy, and a greater emphasis on the fit on the body.

Traditional tattoo styles have been overlapping more and more over the last few decades, and, at the same time, many new influences have been incorporated into the art form. The blending of older, more traditional elements with new design styles cannot fit into one specific genre as the boundaries between these genres have become somewhat blurred. This is the age of fusion, and it has given us an unlimited pool of inspiration from which we can create endless new designs.

There are many factors which have led to this contemporary way of tattooing, the most notable being the development we have seen in the skills and equipment of the tattooer.

The understanding of how a tattoo is created, the machines and the inks we use have become a more important part of tattooing. The tools we use are now finely crafted by those who have worked in the industry for years and today's tattoo machines are to a tattooer what a brush is to a fine artist. As technology has moved forward, so has the skill of the artist holding the machine.

Today's tattooers are often regarded as tattoo 'artists', as they often possess the artistic ability and creativity equal to that of highly-decorated fine artists and designers. No one is surprised to hear that I studied art for years before embarking on my tattooing career; something which would have been unheard of in the industry fifty years ago. While tattooing as a practice is still very much a craft one has to learn and develop over many years, the difference really has come in the artistic design of the tattoos themselves that has stretched far beyond the basic early tattoo motifs.

When legendary American tattooer Don Ed Hardy studied under the traditional Japanese tattoo master Hirohide in 1973, he took inspiration back home with him which he began to incorporate into his traditional tattooing style. This broke down an historic boundary in tattooing as Japanese tattooing had only previously been practised in Japan.

Hardy made the Japanese style accessible and opened up the Western traditional style to new influences. With this new, Westernized style of Japanese tattooing coming to the forefront, it was only a matter of time before tattooing became host to many other styles and influences.

Travel has continued to have a huge influence not only on tattooing, but on art and design more widely. We live in a time when there is hardly a single civilization we do not have access to. Be it through exhibitions, the Internet, collections in libraries and museums, or making a trip in person, we can travel the world in search of new sights and ideas. Many diverse cultures are at our fingertips and the fusion style of tattooing is only a reflection of this.

Generally, the fusion style can be defined by its simple aesthetic qualities but the real artistry of this type of tattooing lies in the ways in which different artistic styles are combined to make a complete design.

Art Nouveau has had a notable influence on tattooing in recent years, particularly on Western tattoo styles, patternwork and tribal imagery. Originally influenced by Japanese *ukiyo-e* prints, the bold, linear, patternwork combined with softer naturalistic floral detailing has inspired a new style of Western traditional tattooing that is much more decorative than the original imagery.

It is obvious that the female portraits and characters associated with Art Nouveau artists such as Alphonse Mucha and Aubrey Beardsley have influenced contemporary pin-up and gypsy girl tattoos, with their combination of realism and outline so suited to the tattoo style.

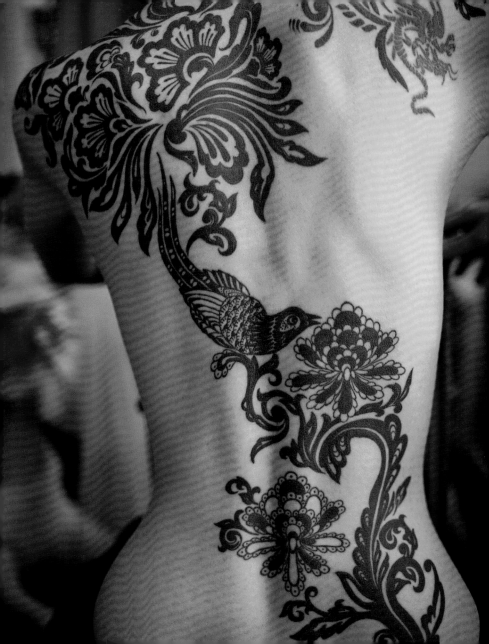

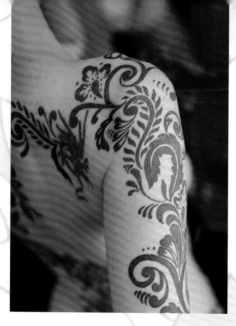

Left: The addition of Kate's sleeve a couple of years after her backpiece just goes to show how naturally and seamlessly a tattoo can grow over time.

Right: Laura's sleeve combines Eastern and Western influences to create this rich, colourful and decorative design.

As a huge admirer of Art Nouveau, I often use this style in my images of women and in floral motifs. The decorative influences of Art Nouveau are now often used to depict subjects from traditional tattooing such as birds, pocket-watches, panthers and women's faces.

Aspects of realism have also begun to cross over into other styles of tattooing, as the flat colour of the vintage-looking traditional tattoos has been replaced with soft shading to create the shape and three-dimensional characteristic we associate with photo-realism; the light and dark graduation and lifelike detailing combining with solid black outlines to create a new style of traditional tattooing, that is now known as 'neo-traditional'.

The addition of a more realistic technique to Japanese-style tattooing has also seen a new fusion style emerge, as the traditional Japanese style has always been instantly recognizable from its graphic nature. Artists such as Sabine Gaffron are a perfect example of how a subject can be taken and executed in a totally different manner, as she blends realism with Eastern imagery to open up immeasurable potential.

Tibetan artwork has also become more influential in tattooing in recent years, both aesthetically and due to the increase in the interest in Buddhist beliefs and lifestyle. While many of the themes are similar to those found in Japanese tattooing: deities, mythical

creatures, folk tales and history, for example, the style is much more detailed and intricate, as well as allowing more freedom in composition.

The time-honoured Thangka paintings of Tibet are distinguished by their bright colours, detail and stylized background. These characteristics have recently become influential in fusion styles of tattooing which just goes to show how far the fine artistry of the tattooer has advanced and how much the abilities of the artists have improved!

The influence of Chinese artwork has also become very strong on fusion tattooing in recent years. The Chinese style is so insistently feminine in its decoration that as the number of women being tattooed has increased, the style has become more and more popular.

Chinese influences are often combined with aspects of Japanese or Western tattoo styles to create colourful and decorative images. Chinese embroidery, ceramics, kites and lanterns have all been embellished with vibrant designs for centuries, so it is no wonder these artworks have become so influential in tattooing. A Chinese phoenix, butterflies, blossoms or even tigers are often tattooed in this decorative style and can be surrounded with traditional Japanese backgrounds, or left on their own.

While Eastern tattoo styles, such as Japanese tattooing, have recently become heavily influenced by the

imagery of Buddhist mantras and fables, traditional Catholic imagery seems to have had a similar influence on Western traditional tattooing. Depictions of sacred hearts, Madonna and child, Christ, rosaries and crosses have become a modern staple of much Western tattooing, as the symbolism of tattoos has become more important.

Taking into account that these are only a few of the many influences on contemporary tattooing, it is easy to see why it is so hard to define a tattooing

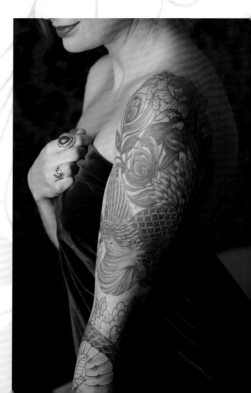

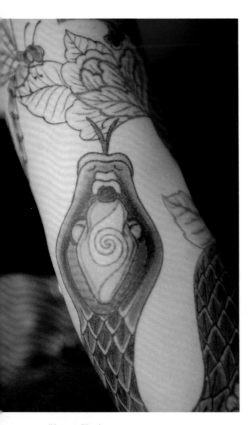

Above: Having known Laura for many years, I felt the spiral pattern on the snake's head embodied her creative personality.

style these days. To think that an image as straightforward and traditional as a peacock could be interpreted in a Japanese, a Western traditional, a Chinese, a mehndi style, or a combination of these, demonstrates how much the fusion of different art and design styles has become an integral part of contemporary tattooing.

When people ask me to describe my tattooing style, I usually describe it as 'Eastern artwork with a Western influence'. The cultures and artistry of the East are what inspire me most; from Tibetan Thangka paintings displaying Buddhist deities and legends and the Japanese woodblock prints of ancient Samurai warriors, to the decorative henna embellishment and intricate Chinese silk embroidery, as well as Buddhist beliefs, Japanese mythology, and Chinese and Indian tradition. However, from an artistic point of view, it is only natural to incorporate these elements into the Western style of my culture, rather than simply try to replicate their original forms.

Art does not progress when it is simply taken from one place and imitated elsewhere; it needs to evolve.

In Buddhist legend, Tara was born from the tears of compassion of the bodhisattva Avalokiteshvara, who wept as he looked down on the world full of suffering beings. His tears flooded together to form a lake, from which grew a lotus flower. When the flower opened, the goddess Tara was revealed.

Green Tara is the Buddhist saviour-goddess of compassion, embodying virtuous actions, the blue lotus she holds symbolizing purity and power. She is at the twelfth stage of enlightenment, able to fulfill all the wishes of any being. She is believed to help her followers defeat any anxieties and fears they have, and is worshipped for her ability to overcome the most difficult situations.

These qualities make the Green Tara a popular tattoo as she is a subject best depicted in very decorative artworks. She can give so much positivity to the possessor, and is such an image of great beauty that the potential for unlimited adornment is any artist's dream to envisage.

The majority of the time, when I have a consultation with a new client, the focus is simply on the subject and meaning behind the tattoo, rather than the style. I have fantastic clients who understand the innovations that I can accomplish by pushing my own creativity, and the boundaries of tattooing and different design styles. I enjoy creating entirely new 'styles' of

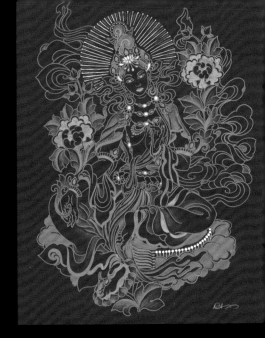

tattoos by combining influences from different genres so I encourage my customers to be brave when looking for inspiration, and to look at influences outside of tattooing. I tell them to look at fabrics, books and at nature itself. I suggest looking in galleries at paintings or posters, and even comic books or films... basically anything that doesn't involve an Internet search for exactly what they want to have tattooed. Why limit yourself to copying something someone already has to signify their individuality when you can find the ingredients to make a completely unique piece of art yourself?

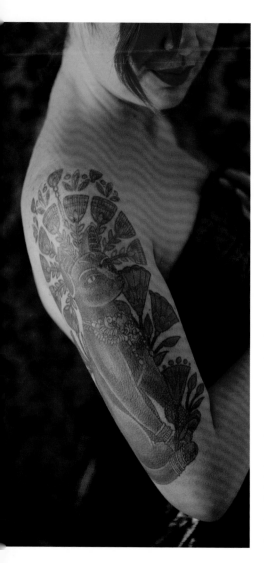

Over the years I have designed two entire sleeves for a client from one vintage shirt discovered at Spitalfields antiques market in London, countless floral tattoos from a book of early nineteenth-century botanical studies, a backpiece inspired by an old Chinese paper lantern, to recount just a few.

The most exciting thing about the fusion tattoo is that it shows that there must be no end to the possibilities for inspiration for tattoos in the future. The boundaries can be constantly pushed, which means that new ideas, new techniques and new subjects will be tried and refined, and tattooing will continue to be exciting and innovative for years to come. While there is nothing any less exciting about the continuation of the old traditional tattooing styles, the new can only be embraced with vigour. After all, while Tracy Emin and Nan Goldin break boundaries continuously with their search for new expressions of art, we cannot ever ignore the timeless beauty of the Mona Lisa.

Left: As a cat lover, Laura wanted her half-sleeve to depict Bast, the Ancient Egyptian goddess of Protection against disease and evil spirits. To balance the the dark colours of the animal, I created a border of decorative Egyptian lotus flowers in tones of red.

One of the most challenging pieces of tattooing I have done in recent years was for Jazz, a trainee lawyer from London. She came to me for the first time a few years ago with an idea for a Chinese dragon tattoo that she wanted down one side of her ribcage, surrounded by traditional Chinese ceramic designs. I took her ideas and began to research them and my explorations led me to discover the Kangxi transitional porcelain of the Qing era. As soon as I found these beautiful works of art, I knew that I had the inspiration to create a stunning and original tattoo. The outcome was one which myself and Jazz were more satisfied with than even we had anticipated, and it took just two years for her to come back with another challenging idea for her other side. This time, she wanted a Bengal tiger, but with a 'Persian nights' theme. Such an unusual combination of ideas sounded captivating and I couldn't wait to begin my exploration into Persian art. My first thoughts led me to the historic Persian carpets, many of which are inspired by the decadent Persian gardens, and the idea of the intricate patterns inspired by nature seemed to fit with the image of the Bengal tiger. I built the design to mirror the shape and movement of Jazz's original Chinese dragon tattoo, and once it was on her skin, it was as though they were always meant to be together.

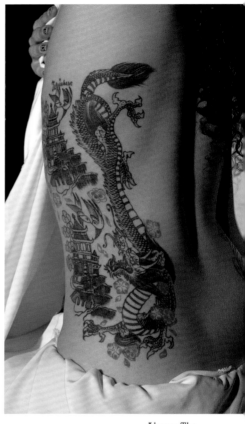

Above: The elegant movement of Jazz's Chinese dragon tattoo works well with the shape of her body.

"The dragon tattoo on my left ribcage was something
I decided on whilst learning Mandarin and studying at
a University in Shanghai. The Persian style of my
right ribcage does not have any symbolism as such
— I have simply always admired the detailed designs
of their patternwork.

"There is no denying that the actual tattooing is
painful. However as each stage passes, any pain is
quickly overshadowed with excitement. It's great to watch
your idea be put to paper and be developed into a much
more creative and inspired design than you'd even thought
possible, then watch it slowly build on your skin session
by session. When each idea first ran through my head,
the prospect of it being completed seemed very far off.
I like to plan my ideas quite thoroughly, so I am sure
about what I want. Once we'd finalized the design, I just
wanted to get it done. I felt great after each tattoo.

"People often ask if I'll ever regret having them done.
I've tried to explain, that once they were finished it
was as if they had always been there and they just became
part of my skin. I feel proud of them."

Jazz

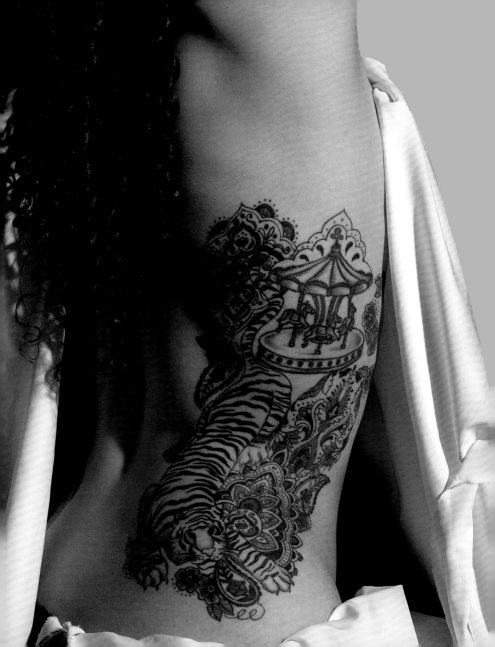

INDEX

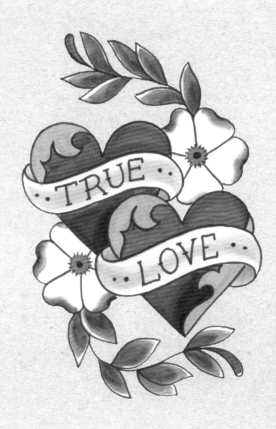

Acknowledgments

First and foremost I want to thank my late
Grandmother for igniting my passion in art –
without her I may never have taken this path. An eternal
thanks to my ever-supportive boyfriend, Oscar, for
everything, including coming up with the title of this book
when I was struggling for inspiration! Thanks to Mo
Coppoletta, and all at The Family Business Tattoo Parlour,
especially Ola and David, to my clients whose tattoos
have made the book what it is, and all the others I've had
the privilege to decorate. Thanks to Scarlett Crawford for
her stunning photos, Layla Drury for her make-up skills,
and Ellen at RPS for all her help from day one! Thanks to
my family for supporting my decision to follow a risky
path in becoming a tattoo artist. Lastly, thanks to all my
friends, and to everyone at RPS for making this possible.

Special thanks also to Little Paris www.littleparis.co.uk
for the use of their location and Oliver Bonas
www.oliverbonas.com for the loan of their velvet chairs.

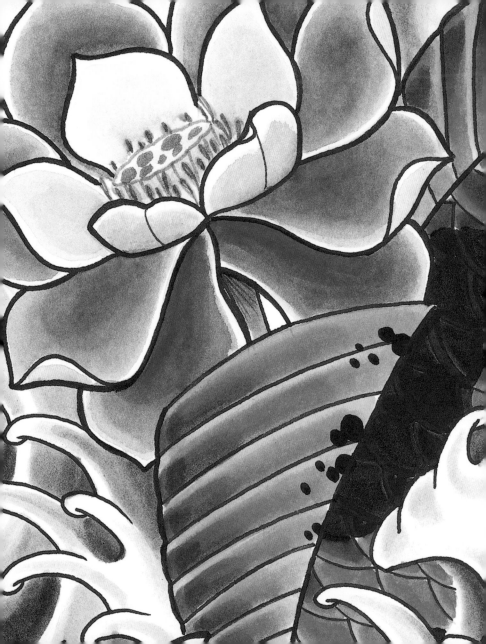